The Theater Years is a catalog of plays that Richard Maxwell and New York City Players put on between 1997 and 2015. The images are derived from videos.

Richard Maxwell
and New York City Players

The Theater Years

Westreich Wagner · Greene Naftali

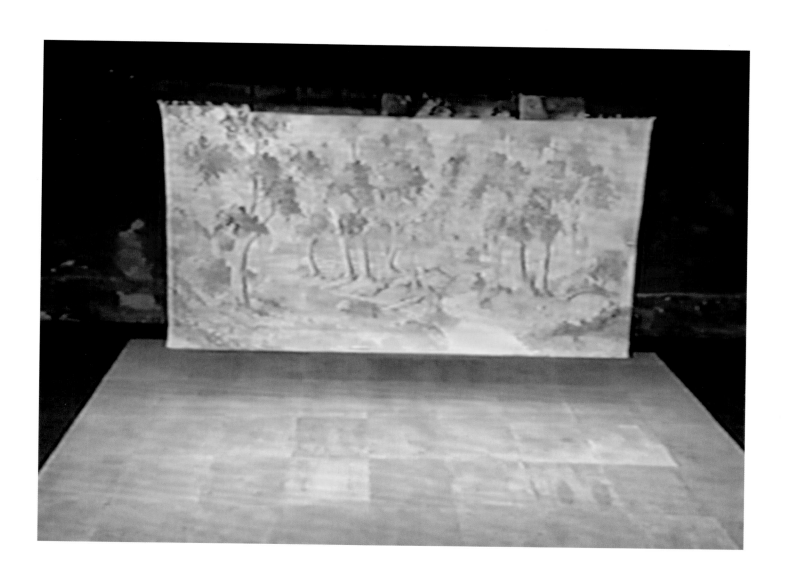

Introduction

I started this theater company in 1999, after making a few shows on my own (credit cards) and a couple with my company in Chicago (Cook County Theater Department). *House* was made in 1998 and travels to several international festivals.

501(c)(3) status is achieved while Barbara Hogue is on board, producing the company's work for seven years. Some of the early designers are Sibyl Kempson, Jane Cox, and Eric Dyer.

The work is staged writing, dialogue between mostly static figures, favoring an American archetype, often accompanied by irony (sense of humor). It embraces low-tech, masculinity, working class types, and an interest in composition, shape, form, then reasons for existing. Text takes the shape of story, people are present, music gets added, scenography, light, costume, acting, even video and special effects...

For a while it satisfies to call the work "pre-conceptual," meaning, we don't know what the work is until we finish it. But that gives way to something like "post-interpretive," having reached the limit of patience for individual or collective interpretations in describing what's going on, or claiming to know what's going on and attaching meaning.

Describe the events with accuracy and an open heart. This is what I will do. After all, there are too many events for interpretation to have solid meaning, or at least any traction of what we call resonance.

I unwittingly hit on a correlative maxim of minimalism.

But how much can be continued like this? I say it's just an unwitting rehash of some dead avant-garde. A retread of meta-theater, a "movement" that until twenty years ago had something to respond to, to get traction from, move against. Now there's nothing here. I'm middle class, hence it's middlebrow, and what could be beyond that? There is only the emotion or feeling which grounds the work. Is there nothing to work with here? Yes and no.

When I moved to NYC to become a "director," I was weary of the decision-by-consensus process that had emerged at Cook County Theater Department and imagined a more efficient method where I would tell people what to do. I also didn't have much patience for reading and doing other people's plays; I wanted to write and direct my own.

The expenses for those early plays were: actors' fees, rehearsal space, theater rental, set, and costumes. I booked, say, three hours in the evening or on the weekend in a rehearsal space. As director and writer, I felt the load on my mind, and found that it helped me concentrate if people didn't move around too much. I was unable to plan much ahead of time since all my spare time was spent writing.

Then something interesting happened; all the effort of putting something together that *resembled* a play I found very appealing. It felt like it set a play free to prop it up like this. And then the job became about following the thing to see what it needed.

Pitting irony against sincerity would become a recurring thing.

Trap doors. Deep red. Earthy greens and browns.

Moments of absurd and astounding silence.

Spam.

A dent in the brass of a trumpet and its sound in the night.

A velvet dress Tory Vazquez wore. Was it brown? Was it purple? I felt like it was dripping off the stage and into my lap.

Now that you know a little bit of the history, what will you do? How will you "destroy" to make room for new ideas?...Before you know it, you are already dismantling. What will knowledge do, in the efforts of that destruction, what will time do?

I want to advance Harold Pinter not retreat from him. I need help. Someone walk me through post-minimalism to now. What a morass, as my dad would say. A ray of hope in an otherwise swill of post-modern mediocrity: The Wooster Group (still my favorite).

Sentimentality will kill all of us even as it cradles. It's got a horrifying grip and it's the lesson I learn too slowly. Full force. Way back then. How perfect is that. Is it time for this, I wonder? Looking back? Why don't we just let it go?

In middle age there is mystery, there is mystification. The most I can make out of this hour is a kind of quiet, a weird rolling night sky. The sky is mixed, but there is some blue, and the motion of people, and the lightness and coldness of the air involve for me a beauty, an almost moral beauty. By this I mean that it corrects the nature of my thinking. Space, perhaps, is what I mean. But there is also light and velocity.

The sets are representational. Cardboard. Wood. Backdrops.

intended. Understand? Someday I will write about this in greater detail. It's hard for me when it's fake and pretentious. But it's difficult to describe what that would be (fake, pretentious). Lately, I started thinking that even there you can see a huge fragility and that is beautiful.

There are people on stage. They are wearing clothes, drinking, eating, watching TV, playing instruments, speaking words. There is space between the people and their words. I am drawn into that space, that gap. And suddenly I know. I realize. We're all in that space. It doesn't matter who I am. I'm not really this name, these clothes, this body. I'm here, now, in this space with you.

Try to work out to an edge. Try to get by. Make a play in a hotel room, for example.

The question comes up of doing some kind of showcase during the Association of Performing Arts Presenters conference (APAP), an annual networking event that takes place in hotel conference rooms in NYC, where artists vie for their work to be seen by venue representatives. The solution was *Showcase*, first performed in a room at the Hilton—the center of the conference. About a dozen people were ushered in and seated on one bed facing Jim Fletcher, who is stretched out in the dark, nude, on the adjoining bed. Lying next to Jim is a figure clad in black, Jim's shadow.

Jim's naked. He checks his phone. Is it the right hand or the left? Can't tell. Use peripheral vision. Not easy in this mask. Sometimes my nose itches, or my eyes burn. Sometimes I want to sneeze. There's nothing I can do about it.

I always try to pee before I get into my costume, but sometimes I don't have the urge. That's problematic. One night in London I was wrong, and just in the final moments, when Jim was singing the song, I had a disaster. Lying there nightly, listening to those lines, I get pictures. When I hear "train, the coldest night, the red light, the bar in the hotel," I see Paris or Berlin. I once asked Jim what he saw. He said, "Columbus, Ohio." The chorus girl from 'The' and the room where she parties. That's at 43rd and 8th. In the Times Square Hotel.

When I get up to open the curtains, to turn the light on, and walk to the bathroom, I pass people, but don't really see them. Just shadows. I go into the bathroom and close the door. Jim is speaking, but in twelve years I've never heard what he says. I lift the toilet seat, make a peeing sound, and flush. Last week in Los Angeles I got the perfect peeing sound. After twelve years I got it right.

How did I do it?

I thought I should be content to just enjoy it and not need to know about its authenticity.

Anyway, I ended up being unable to accept any formula for enjoyment. I sometimes wish that I could. I think there must be a parallel in theater to the films of Budd Boetticher for example: B movies done without fanfare with meat and potatoes plots. And then at the end of the day, you punch out. I aspire to a certain unpretentious economy, but I'm also interested in the more intellectual ramifications of that economy. I get wrapped up in the cerebral facets. The act of conscious repetition encourages reflection.

It's funny that acting is seen as the opposite of thinking, like "Time to stop thinking and start acting!" Or "Act, don't think!" Whereas, it's really, "Good acting is the quality of thought."

I watch the actors with a pleasure and terror; it's always on the edge of embarrassment or failure. There is always the relief of the thing taking off. Same thought staring at huge metal airplanes on the runway. No way can this fly.

Viewer empathy is hard to come by and subject to change. You declare this person a character and the judgments start flying, challenging the viewers empathy and emotions. I am convinced the human figure is inherently offensive—the human body, the actor invites critique. Imagine plays that you've seen without any humans and you start to see what I mean. Theater could maintain the cool detachment that a gallery or museum offers were it not for the humans. And if sets could move and take direction and talk to me about their experience, I would probably just work with them...why robots have figured in my work. A human being is supposed to know better and play along with certain notions of verisimilitude. Makes it hard for an actor to feel like a formalist pioneer playing like this. This is why we call them actors, they pretend to have a soul.

What do I want? Integrity and problems. The audience can be pleased and bored at the same time. Do they like theater, I'm not sure. Do I like theater?

What do I want? Gloves off. What do I not like about theater? The sitting around for experience.

I witness one of the performers go off script and begin to challenge the politics and nature of the production itself—a theatrical bomb, a strange and beautiful ode to openness.

The writing. People look to other writers. They say old modern writing like Gertrude Stein and Ernest Hemingway. I try to go online, to the NY Times, to recall how they have compared the writing's lack of carbonation. I use my mother's iPad. She is out of free articles. Our songs remind people of old radio hits from the 70s-80s, timeless childhood songs, eternity FM. Power ballads done in a weak way. I can relate. It reminds me of the spiraling voice inside but acted out, with an outside voice. Feels semi-unconscious, like a daydream or thinking while driving, distracted, not fully in control of itself, gasping for itself, also making a mental space...when words are really doing that. What real feeling of freedom...

Now, finally, I seem to be allowed officially to write real stupid, as I always wanted to, and as I was sometimes even told to do. No big expectations now. Like being an artist. You learn about the difficulties to become a real professional artist, that your work needs at least a little injection of stupid in order to make it a good work, in order that it can achieve a certain amount of communication value. "You guys, oh my god, you guys."

By the way, I also don't need to be here. And much of this work is pretty boring. Even this is kinda boring. If it weren't for the conversation with people inside a production, which I find so necessary, so familial, I don't know what I'd do. I realized something I have always known: that the Whole is impossible, that knowledge is the classification of fragments such as these.

Songwriting felt so natural in those Chicago plays. I was in the time of their words, the time of their gestures, the time of their story. I was not anywhere else and I had the feeling that it was a rare and good temporality. Music is something that is available; movement and speech, primary/ancient ingredient of theater. And something that doesn't cost anything. It informs much of the conversation with the actors: time (and timing) is a recurring topic, rhythm, listening, awareness of others, playing with others. Notes and rests.

I trust silence, because of all the information that floods out anytime an individual steps up in front of people. We are habituated to consciously tune in when someone speaks. But when they stop speaking our unconscious tends to take over, or at least silence loosens the contract between actor and audience; the viewers' psyches rush in to fill the void. There seems to be more possibility in the air.

When a play is too consciously put together, it bothers me, as you can retrace the steps too quickly, too easily. One shouldn't really talk about this, but I think everyone who makes things

knows there is a moment, prized, when a third hand is doing the work. One show, the power cut out, and everything disappeared except for the actors' voices, and it was just, I don't know, this black envelope, a long run of silence, and then relief. Everyone in the audience was relieved, to tell you the truth, they didn't have to look at the actors anymore. Maybe the making of this mistake expressed the very purpose of the play's life and the essence of our being here. After a few minutes of silence, someone near the stage starts saying "fuck face, fuck face, make a mess, fuck face, fuck face, you're the best."

I came to a curiosity, I guess you could call it, about how the thing would break in time or across people, which is also how people feel about a game. It wasn't a kind of curiosity like I would think about it, more like when you listen to a version of a standard and you are hearing the changes, naturally alert to it. It was kind of beyond good and bad, although somehow something can be off. If I recall, that would often be attributed to a lack of focus or energy.

Back in those Cook County rehearsals, one thing was agreed: the moment on stage, in order to be vital, has to be available to possibility. In NYC, after 15 years or so of extolling the virtues of *not* pretending, I found myself asking these actors I knew so well, "Are we afraid of pretending?" Or, have we eliminated that possibility?

One of the actors further clarified the problem: pretending is a thing that people do, like walking—sometimes we even pretend to be not pretending. Let's acknowledge it as a complex mode that is always there, and always available, just as the "real" is, whether you are attentive to it or not. Let's be attentive to it.

So we performed another turn in the conversation regarding behavior. We could not have done this in any other grouping of performers. The history made it possible. I was lucky we were still together. I have relied on these people in ways beyond the work on stage:

Laura Dern

Martha Graham

Isabelle Huppert

Venus Williams

Maria Sharapova

I don't really know what theater is, maybe that's what I still like about it. I have a thought that theater requires metaphor—but

I'm not sure it's really metaphor I mean, it's rather that some other place and some other time is laid over what is happening onstage— and if there isn't this double vision then it's something other than theater that you made.

Take *Ads*, a show in which all the performers were recorded separately on video, without interacting. In fact the performers were tied only by the same series of tasks: step up on an apple box; turn to camera; read from the teleprompter a five-minute statement they each had written about what they believed in; turn away from the camera; step off the apple box; walk out of the frame. In the finished production, the audience might or might not detect or deconstruct these tasks exactly, but they were points of concentration that united the performers. Far from being able to remake ourselves, I felt theater coming undone. This play had an eye for removing all that you can from the stage while still having a play. No live actors, no writing produced by the playwright. No music. A virtual temporal structure as the container for the content which was brought in by the participants themselves. People as ghosts trying to be real.

Characters are like ghosts in this way—they can't be killed, for example, like people can, and yet they're not alive. Which is perhaps what makes stage combat so amusing—that an individual, in order to help tell a story has to execute certain physical sequences in order to be convincing, yet safe. It's a wild state to be in. It points to the artifice inherent in repetition. Don't punch so hard that you can only afford to do one performance, but punch hard enough to make full-feeling contact. It's a point of concern with realism, and one that I find entertaining.

Another is the concept of neutrality on stage, if only because of its utter futility. Attempts by an individual to take stage in a neutral way cannot contend with the many automatic and subjective associations of the viewer. It does, however, create a useful conversation.

An actor who works with me points out that the pursuit of neutrality (as in a performer trying to split the difference between two opposed adjectives, e.g. happy or sad, energetic or lethargic) has value in that it allows us to approach the "split consensus," a more intense place—where one doesn't know what to think, for example. So that neutrality is actually a place of high suspended charge rather than of no charge.

What color is more neutral, white or black? Most theaters are painted black to become neutral, not considering what it means for a black performer to be in front of a white audience. Shouldn't a black person have the same claim to neutrality as

a white? Why make a theater black? I would say it's to eliminate exterior world and enable a transportation by the viewer to a fictional place. Like dreams. This doesn't make black neutral. But neither is white or even grey. What gender? Age? It's like the old idea of, when you meet someone in heaven, in what form will they be? At what age, and wearing what?

But I would hate to be put in the place of having to decide between realism and neutrality, as they feed on each other. In the accumulation all this looks great, you can look at it that way, but keep in mind how shitty it is too. Just like they say about water, you can say it about theater too: "Fish fuck in it." Water is great, and simple. Even sublime. But...

People sometimes ask, why do all this work thinking about freedom for audience when the audience will make up their own mind anyway. Why not do what most plays do—try to get as many people feeling the same? To say that they make up their minds anyway doesn't factor in the widening of the frame to include the room and the people in the room.

Audiences also have a collective dimension, like it or not. And audiences want to enjoy the show. We have a will to enjoy. This is unavoidable. Also, we want to be a good audience. But we don't worry about it too much. We are less neurotic than the average individual. And we'll drop you as soon as we're done with our obligation to you, even if you put us in a fucked up position, which may involve laughing and clapping.

Would the performance still be valid if you were not heard? If there was no audience? Two examples come to mind: the Charlie Brown TV show where the adults talk but are just like "wa wa wa." The other, John Cage doing a reading, commemorating Erik Satie. He said, a string quartet is playing the music of Satie somewhere else in this building while I read here with you.

Rich said, you could just read the work at home. I thought not. The musicians were in the building and you could get up and find them.

I like seeing my friends on stage. Their writing, their bodies, and their work. I like the ritualized exposure to the human element and the human audience. I also like being involved as an audience. We are exposed too.

When watching a play you rehearse for your reaction afterward, how you will describe the play, what your opinion of it will be, if you can say anything intelligent about it. I try to let the play grab my notice, as it does.

That said, I try hard to stay at attention—I am not very observant, am lazy about observing—I always make the attempt to be observant, but I never observe anything that way. And then I relax back into lazy in-observation. I remember a specific experience—hearing a statement, visualizing an image and sensing a concept. They are distinct nodes in my brain that somehow lined back up. I am activated.

I do the pie-in-the-sky thing that I always do with artists where, on the moment-by-moment surface I'm inadvertently tracking my own barometric experience and understanding: Are there any easy guarantees? Is he "doing himself"? Where and how? Did the rigor and face-in-the-wind questioning and problematics drop? And then...what am I doing.

What do I want?

Integrity and problems.

What bothers you?

The enthusiasts

The set up

The sitting around for experience

The fact that nothing happens

The fact that people are struggling with themselves

That it's boring

That it demands so much of me

What is it for

The fucking lobby

The social problem

The men

The sound of the floor (I mean the way that sound makes a total joke of life and living and being)

Like lilliputian fucking mice

Rabbits

What men?

I see the morbidity in all this. On Sunday, we see Blue Man Group, and I feel I will get it all back. I think: man versus man, man versus himself, man versus nature.

If you like to tell the truth, the landscape is going to happen. Both studied, illegal or otherwise intelligent engagement. But

for me, they will be evaluated to determine the true picture, as strange as it seems. To create a unique point A to point B. A better understanding of the experience of playing the game and the basics of playing the game.

The "theater-is-theater" argument is: you want to show something, then show that thing. Simple. This is what people tell me when they're trying to tell me something. I got the message years ago: "Don't get fancy." That feeling of anticipation is there no matter what. A great feeling. It does not have to be plush seats and angels.

The theater-is-theater argument has kept theater behind the other arts and I'm trying to figure out why. Why, for example, would you deny a whole spirit of modernism, going back to Manet. Denial that extends all the way through Judd and Warhol. And the answer can only be: Joe Blow. The person who expects an hour or two of something that they could interrupt, if they wanted to. In the other arts, the artist is hero, and we strive to put ourselves in that genius's shoes.

In theater the people are there with all the other creators. And for this reason it will remain behind the other arts. It is magic. It has been around for a long time and I certainly hope it continues.

L-1

Billings

A man and his wife are moving from Billings to Minneapolis. Three movers pack up the house. They all travel by Amtrak to Minneapolis. On the train, the movers talk about their anger towards a co-worker. They think he has it easy and doesn't deserve what he gets. In Minneapolis, the new house is half the size of the old one, and the furniture makes it impossible to move. The wife tells the men that she is a spiritualist and a seer. The movers ask to be paid, and the man pays them. The movers sing about going to the Vikings game.

Written and Directed by Richard Maxwell

Man Josh Stamberg
Wife Beata Fido
Mover #1 Lapka Bhutia
Mover #2 Kevin Hurley
Mover #3 Gary Wilmes

Lights: Jane Cox

Ontological-Hysteric Theater
New York 1997

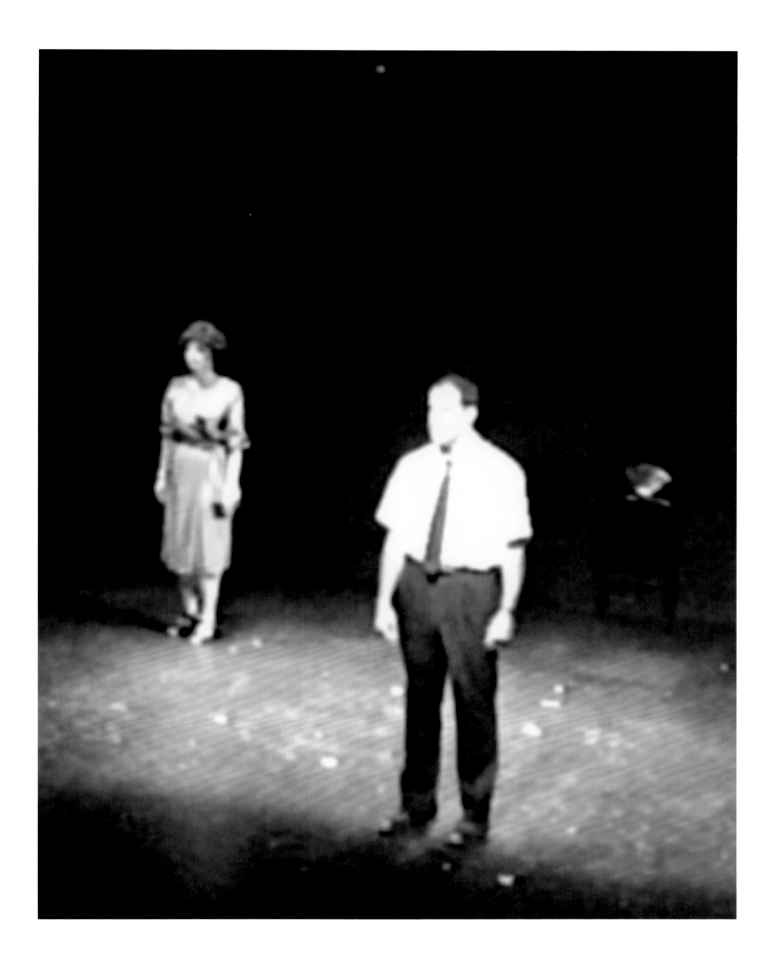

 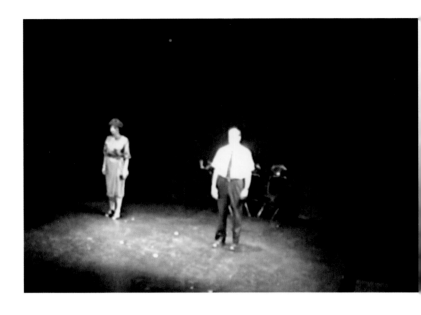

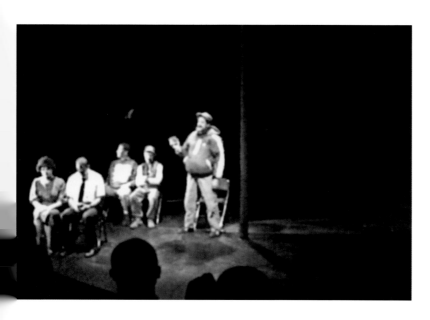

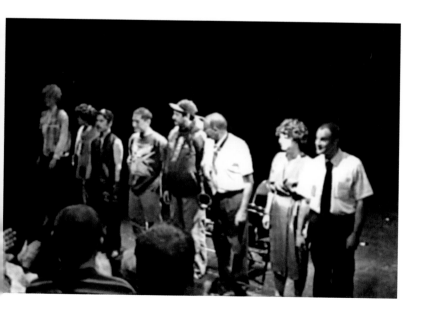

Flight Courier Service

Rene signs up to be a flight courier. Carolyn, from Couriers
International, sends him to Kuala Lumpur on a one-way
ticket. On the plane, in front of Stewardess, he opens
the package he is meant to deliver. When he arrives, Mr.
Feldman, the package recipient, asks him why the package
is open. Rene makes an excuse. He gets a funny feeling and
escapes out the window, wrestling along the way with Lakpa,
Mr. Feldman's associate. Rene wanders the streets and runs
into Stewardess. He asks if she can help him. Lakpa and
Mr. Feldman want to kill him. Rene and Stewardess have
sex. Stewardess tells Lakpa and Mr. Feldman where Rene
is, but then she takes him to the airport to help him escape.
Rene gets on the phone with Carolyn, who says they can
send him with a package to Seoul, but he may not return.

Written and Directed by Richard Maxwell

Rene Josh Stamberg
Carolyn Kate Gleason
Stewardess Kate Walsh
Lakpa Lakpa Bhutia
Mr. Feldman Bob Feldman

Costumes: Sibyl Kempson

Ontological-Hysteric Theater
New York 1997

 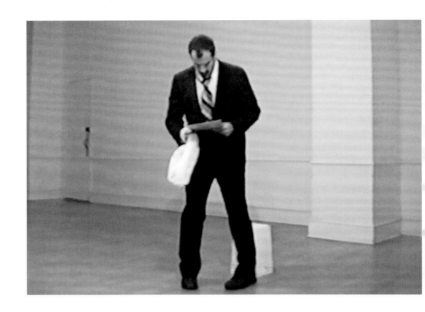

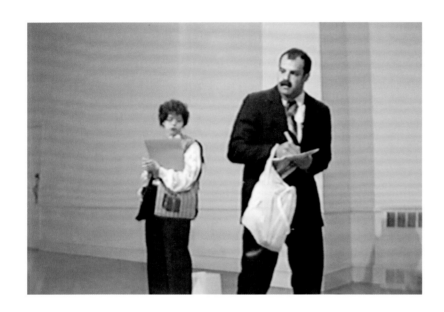 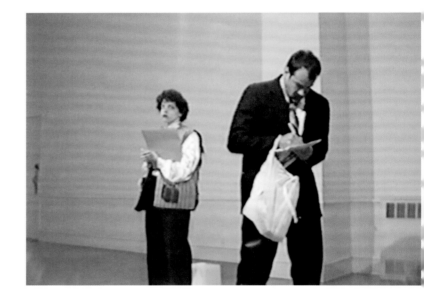

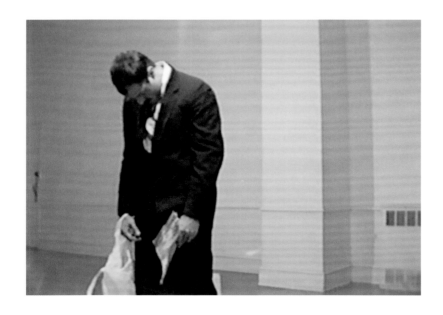 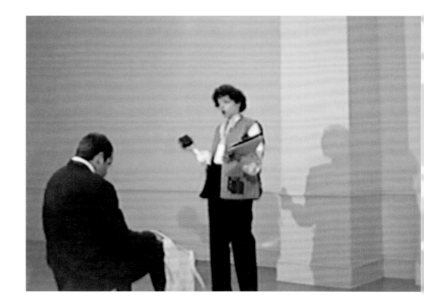

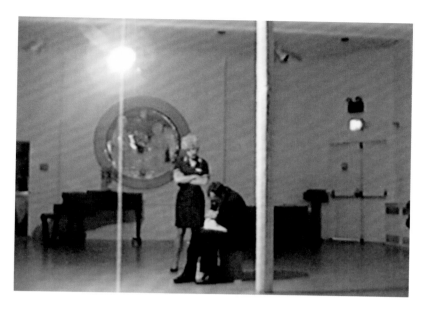

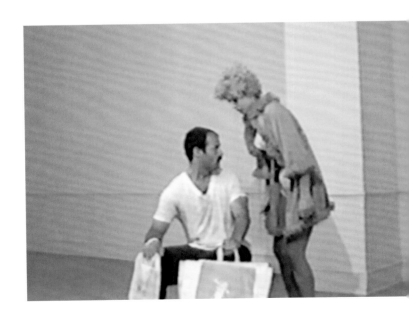

Burger King

Donald is the devoted manager of a Burger King. Oral is the
Shift Coordinator. Sherry and Bef are employees. Sherry has
a crush on Oral and also wants to be Shift Coordinator. Bef
is trying to get Sherry and Oral to sign a letter of demands
to give to management. Donald regularly meets with his
employees to inspire them to better service. The District
Manager comes to visit. Donald tries unsuccessfully to talk
to him about making improvements to the store. Donald
admits to his employees that he has on occasion served
customers bad meat because he was too embarrassed to admit
the store had made a mistake. Oral becomes the manager.

Written and Directed by Richard Maxwell

Donald Christian Lincoln
Exterminator Josh Stamberg
Oral James Stanley
Sherry Chevon Rucker
Bef Kate Gleason
District Manager Lakpa Bhutia

HERE Arts Center
New York 1997

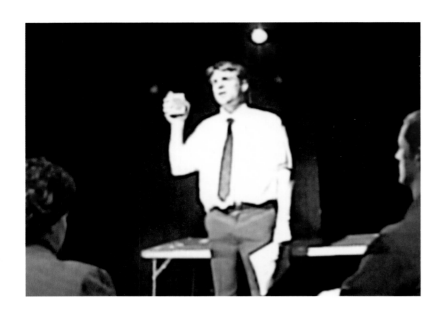

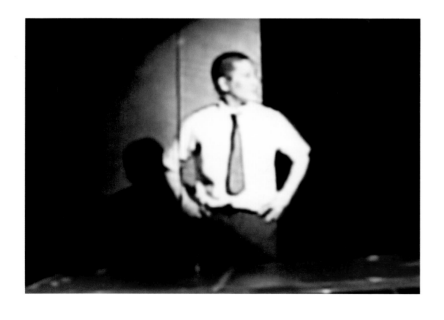

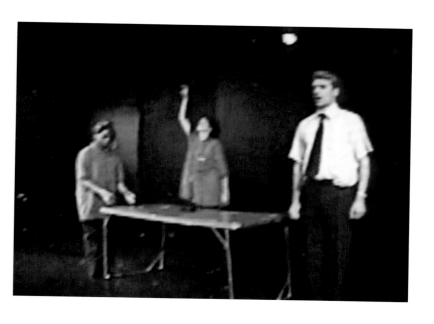

Ute Mnos v. Crazy Liquors

In the courtroom, testimonies are given regarding a bar fight
at Crazy Liquors where Ute Mnos had his leg broken. A
barmaid, Kim Geever, bouncers Randall and Terry, and Crazy
all give testimony. Ute is absent, as he has no recollection
of the night in question. At the bar, on the night of the
fight, Crazy tells the bouncers how to do their job without
making trouble. Ute is very drunk and tries talking to Kim.
He provokes Randall and Terry and gets thrown out. Randall
admits to Terry that he broke Ute's ankle by jumping on his
foot. Ute wins his case and buys a motorcycle.

Written and Directed by Richard Maxwell

Bailiff / Daryl Ryan Bronz
Judge Bob Feldman
Joe Yehuda Duenyas
Kim Geever Emily Cass McDonnell
Prosecuting Attorney / Mike Lakpa Bhutia
Randall Gary Wilmes
Terry Jaymes Brevard
Crazy Jack Doulin
Ute Mnos Kevin Hurley
Soapy Ford Wright

Band: Andrew Bergman, Nicholas French, Chris Kirkman,
Jamie Montgomery

Set and Lights: Eric Dyer
Costumes: Sibyl Kempson

Eden Arcade
New York 1998

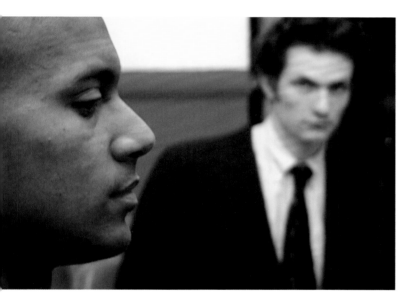
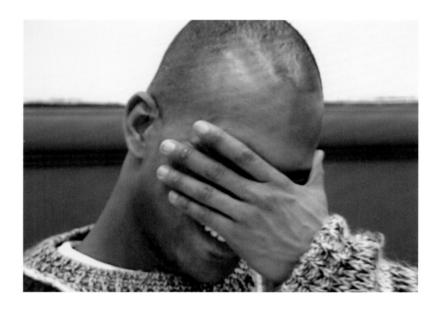
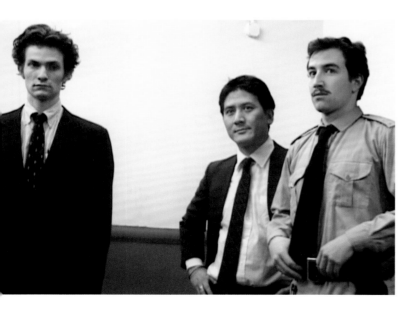
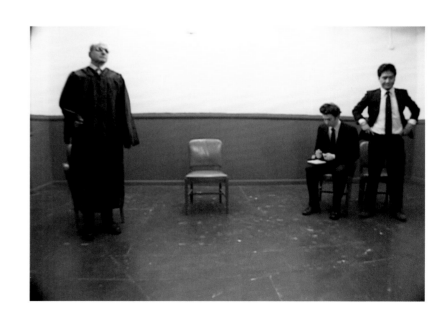

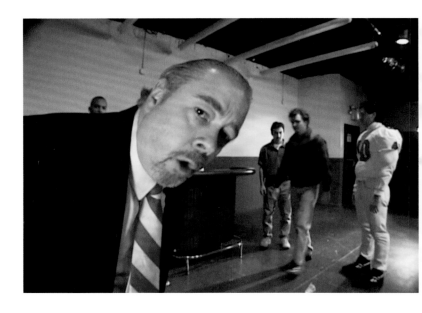

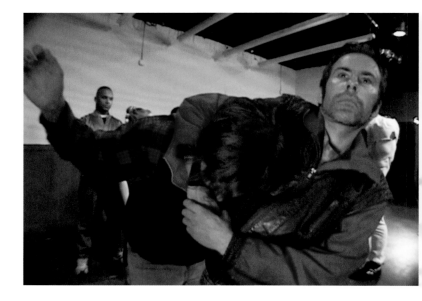
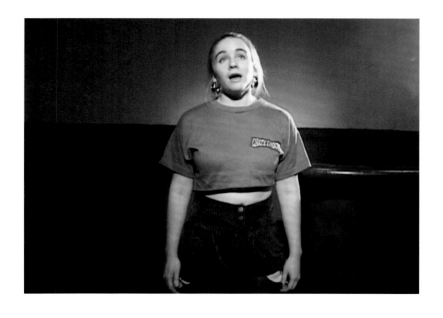
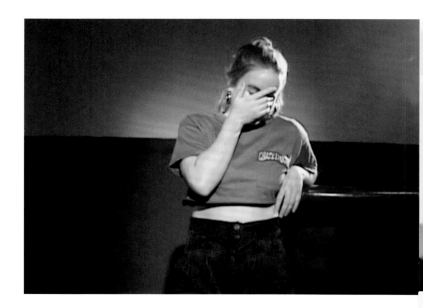

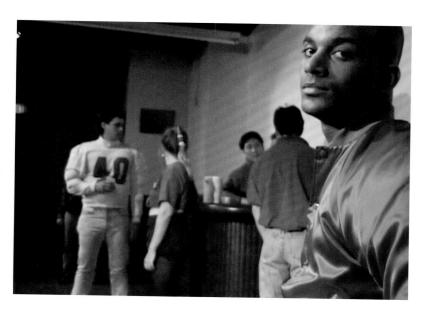
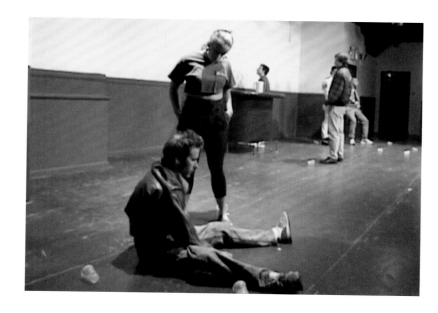
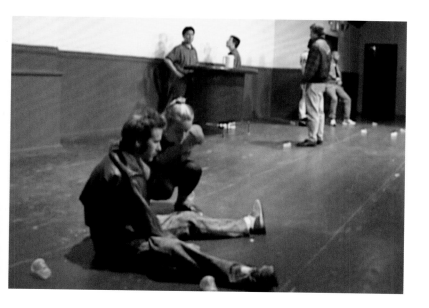

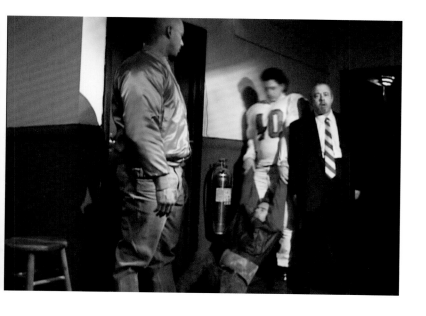
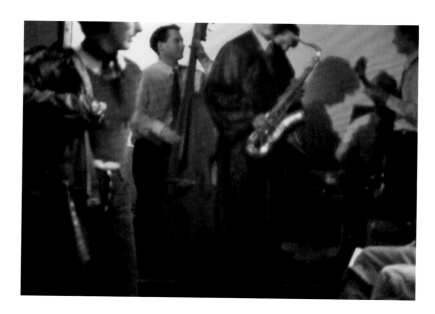

Eden Arcade

House

Father tells Son what he knows about the world, failing to answer key questions about his past. Wife talks about finding a better place in society and what might be best for Son. Meanwhile, Mike talks about working for the government where somehow his brother was murdered. Eventually Mike arrives at the house and accuses Father of killing his brother. They fight and Mike kills Father. Wife and Son escape and live on the road for a year. Wife and Son return to their house to find an occupant, Mike. Son is killed by Mike while trying to avenge Father's death. Mike persuades Wife to go with him.

Written and Directed by Richard Maxwell

Father Gary Wilmes
Wife Laurena Allan
Son John Becker
Mike Yehuda Duenyas

Set, Lights, and Costumes: Jane Cox

Ontological-Hysteric Theater
New York 1998

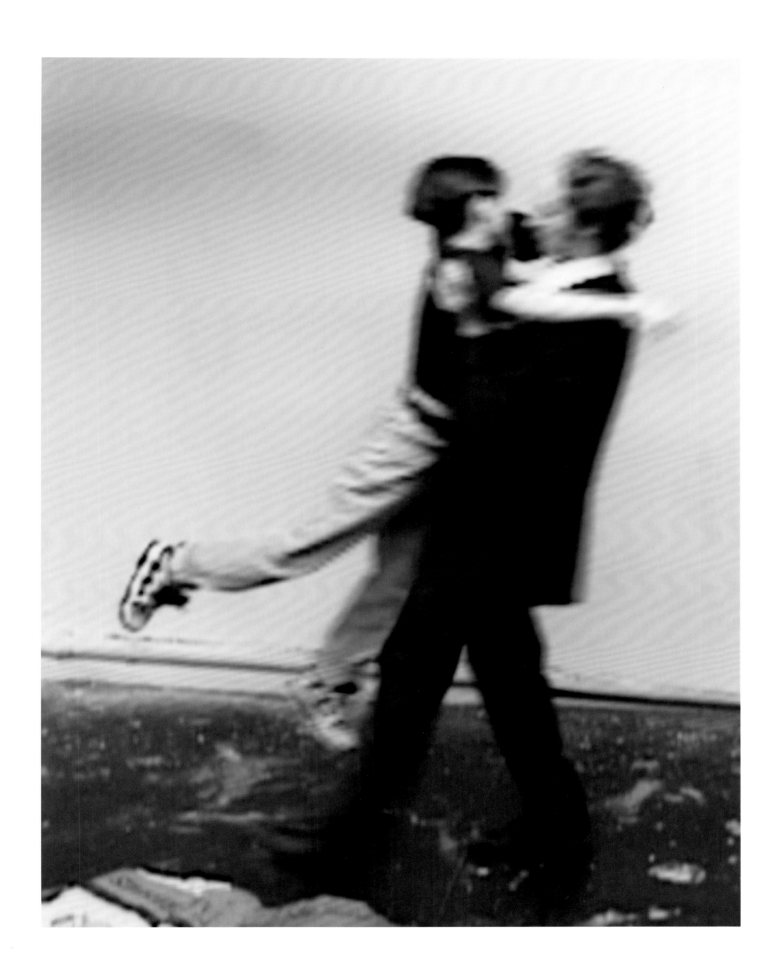

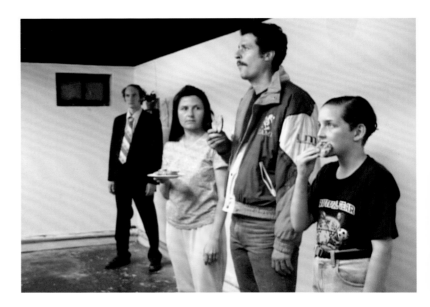
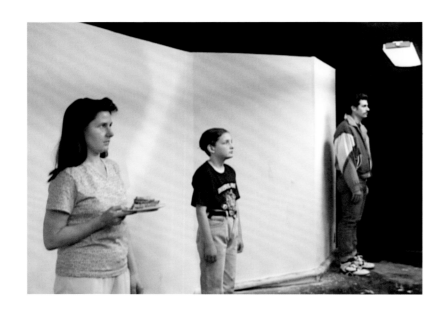
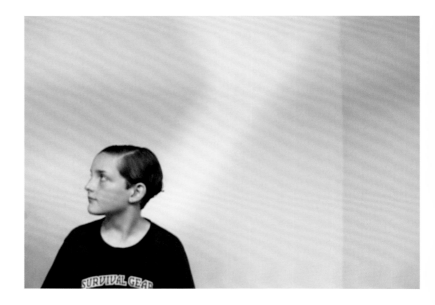
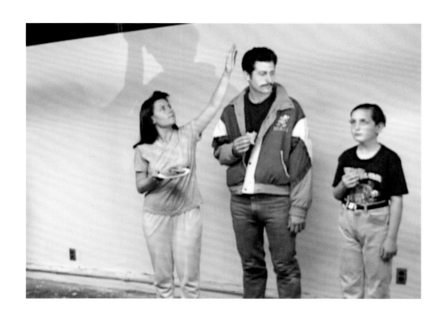
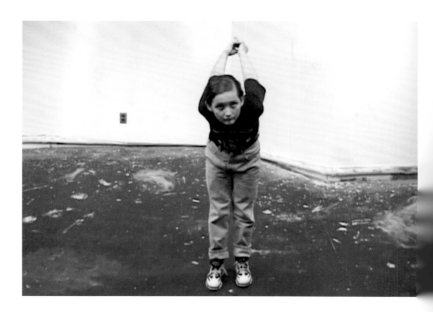

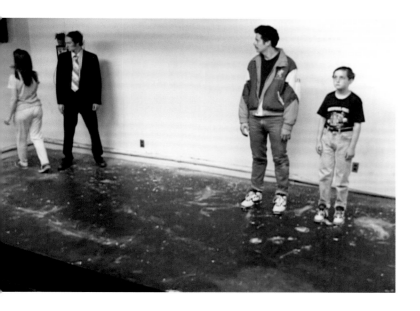
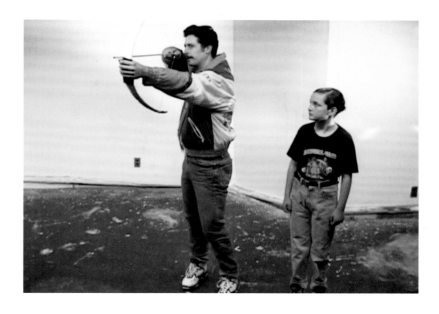
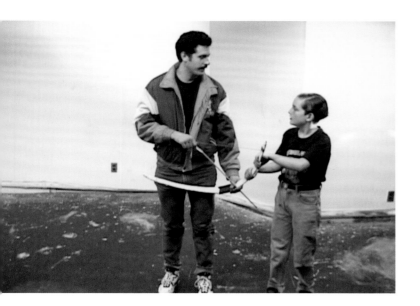

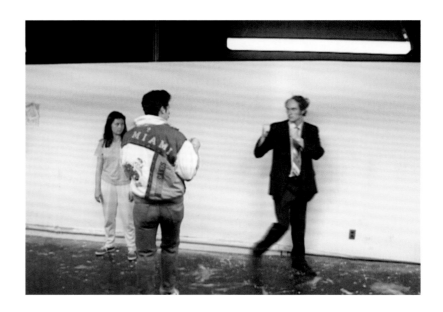

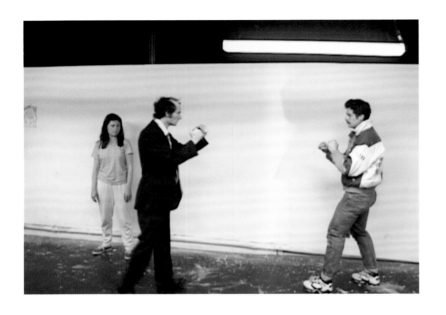 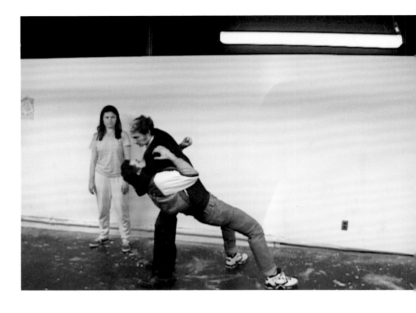

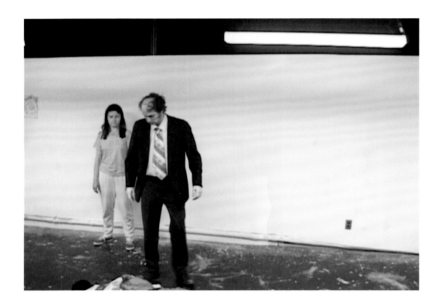 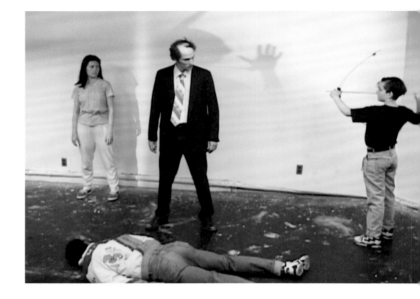

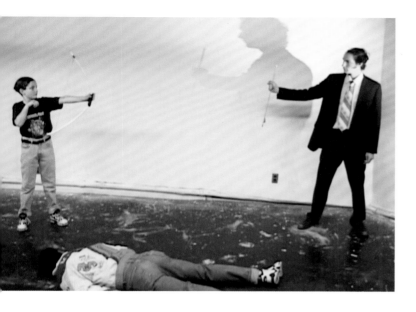 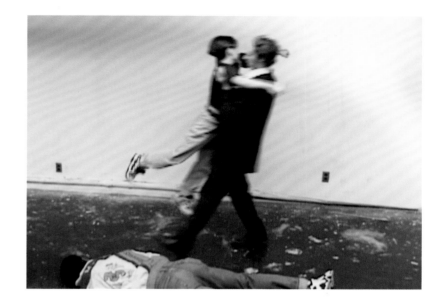

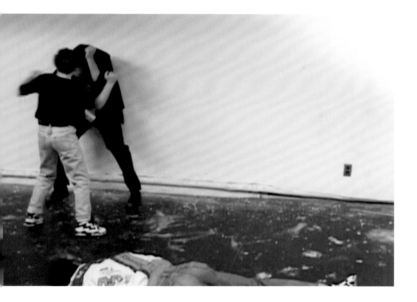 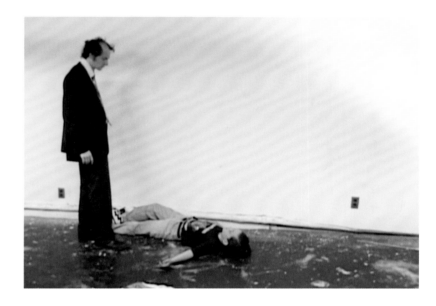

 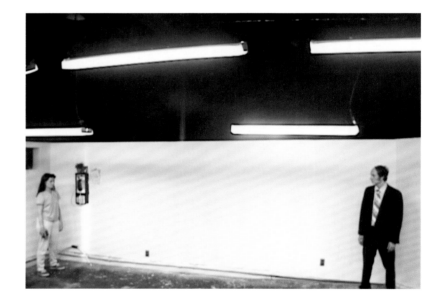

Cowboys and Indians

Francis and Quincy, two Harvard students, prepare to travel
to the Great Plains to study the ways of the Indian. Francis is
determined; Quincy is a layabout. In a saloon in Saint Louis,
they assemble their team: Captain Chandler and a guide, Henri
Chatillon. Pa tries to get hired but is rejected. Pa and Ma,
traveling preachers who warn of the ills of the plains, decide
to go West themselves. On the plains, Francis addresses the
group about the history of the Indians, whom he claims came
from China. They travel and sing. Quincy and Henri abandon
the journey. Francis and Captain Chandler meet with Chief.
Captain Chandler is killed by an arrow. Chief tells Francis
about his love for the whites and about his people's past.
Francis and Quincy return, Francis with a strange infirmity.
Francis still wants to write about the Indian Wars.

Written by Richard Maxwell and Jim Strahs
Directed by Richard Maxwell

Francis Parkman Pete Simpson
Quincy Adams Aaron Landsman
Mather Parkman Paul Lazar
Imogene Wentworth Julia Jarcho
Henri Chatillon Eric Dean Scott
Pa Thurlow Ford Wright
Ma Thurlow Joanna Meyer
Captain Chandler David Cote
Squaw Sally Eberhardt
Madam Laramie Okwuchukwu Okpokwasili
Chief Lakpa Bhutia

Musicians: Scott Sherratt, Chris Kirkman

Set, Lights, and Costumes: Jane Cox

Soho Rep.
New York 1999

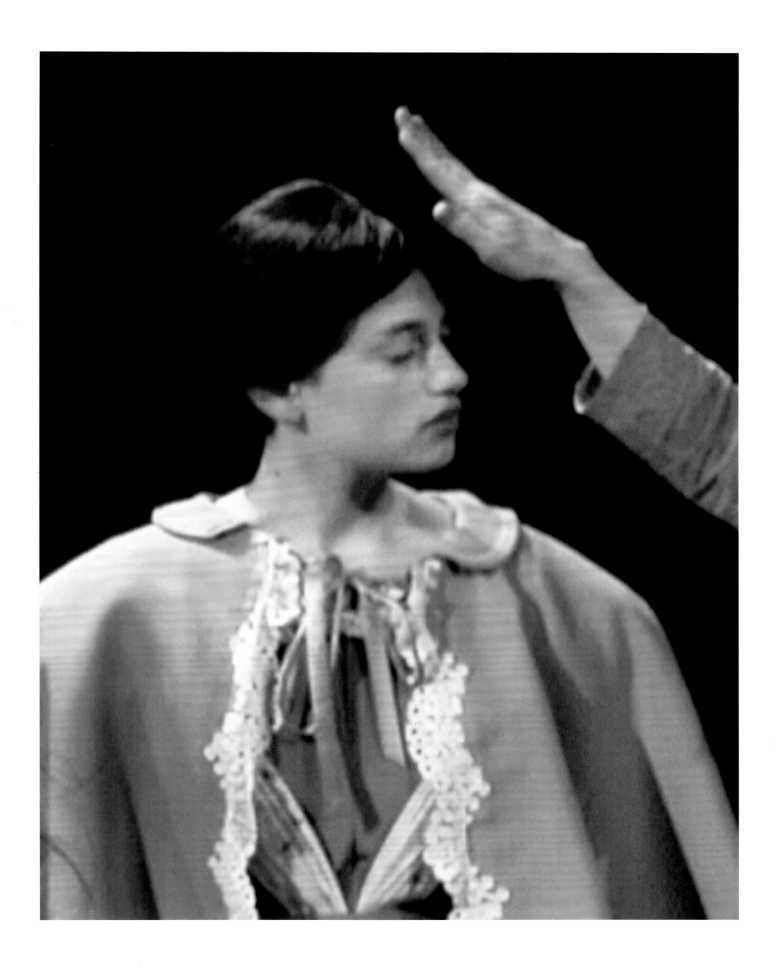

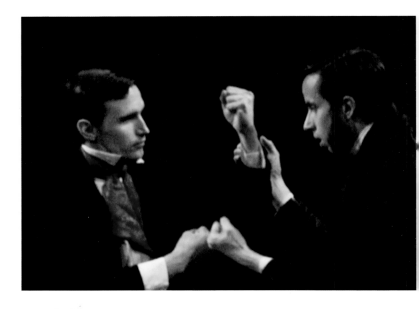
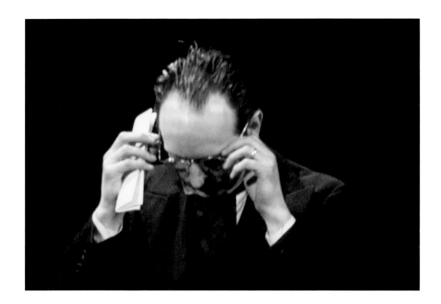
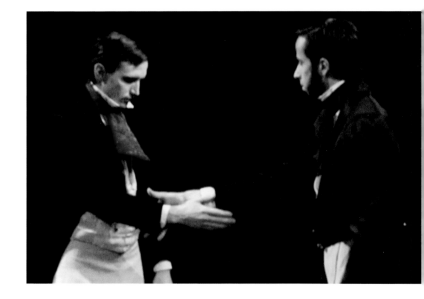
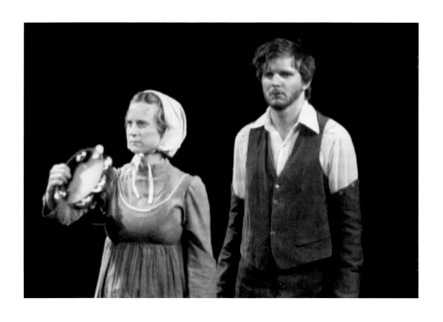
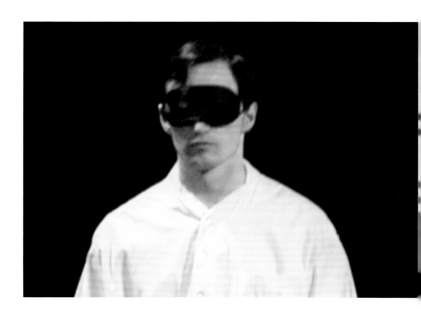

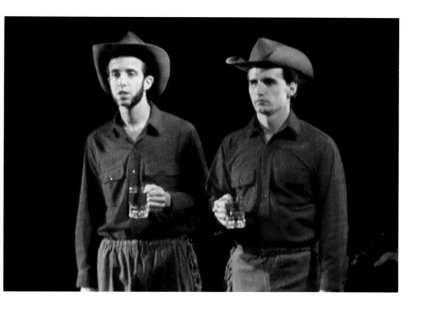
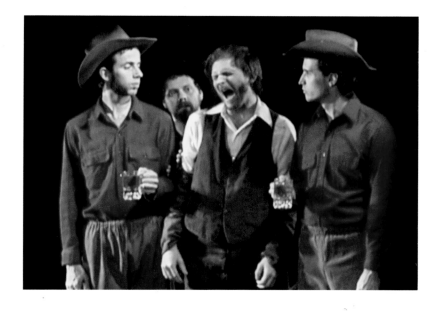

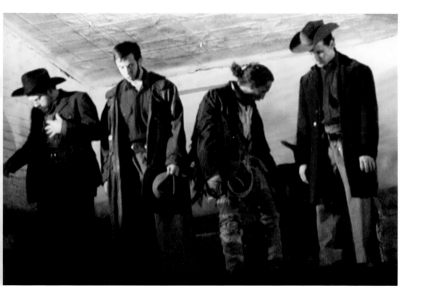
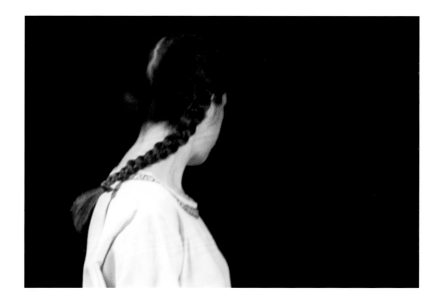

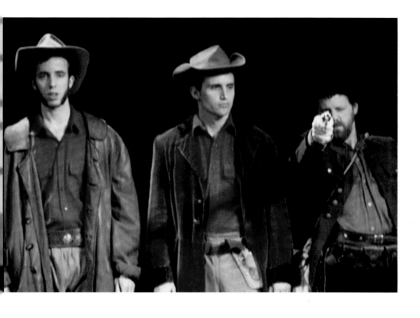
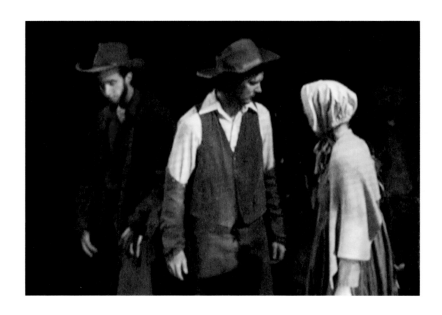

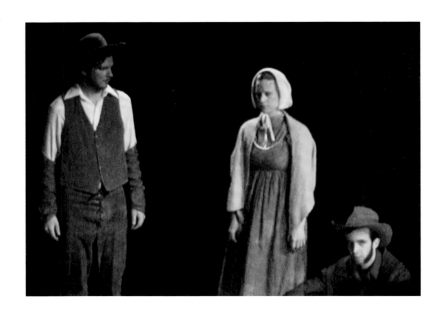

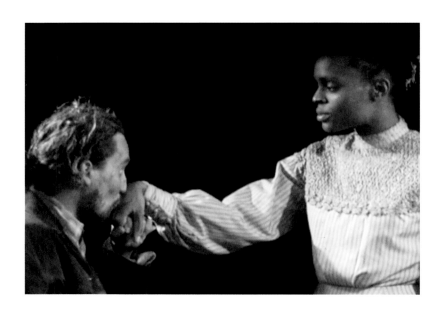
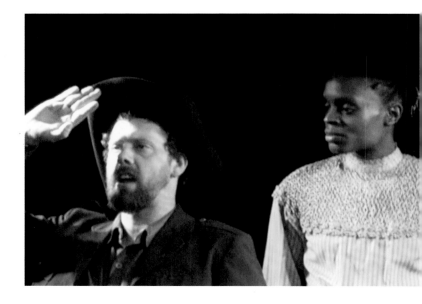

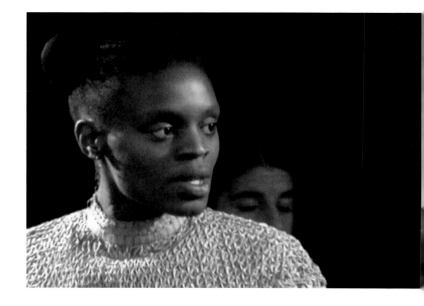

Showy Lady Slipper

Lori, Jennifer, and Erin are friends. They talk about driving,
travel, horses, and men. Lori and Jennifer fight about Tracy, a
woman they know who' had some success in graphics. Jennifer
gives Lori a necklace she made and they make up. John, Lori's
boyfriend, a race car driver, comes by. The women show him
the clothing they bought. John asks Jennifer to go driving with
him. They kiss. Lori sees them and John leaves. Lori throws
Jennifer to the ground as the phone rings: John has died in a
car accident. The women sing.

Written and Directed by Richard Maxwell

Lori Sibyl Kempson
Erin Ashley Turba
Jennifer Jean Ann Garrish
John Jim Fletcher

Musicians: Bryan Kelly, Scott Sherratt

Set: Joseph Silovsky
Costumes and Lights: Jane Cox
Producer: Diane White

Performance Space 122
New York 1999

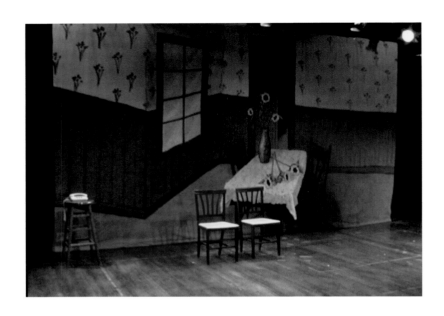

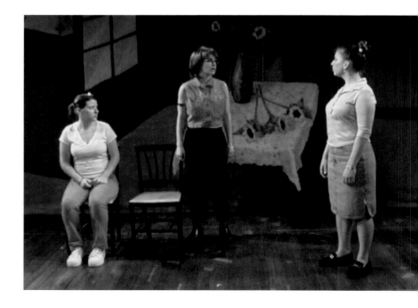

 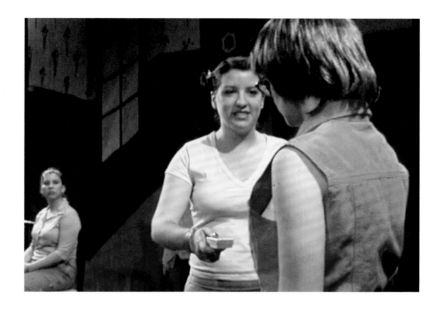

 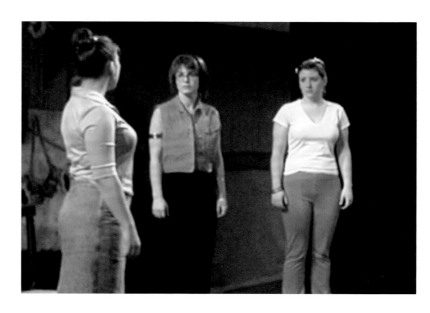

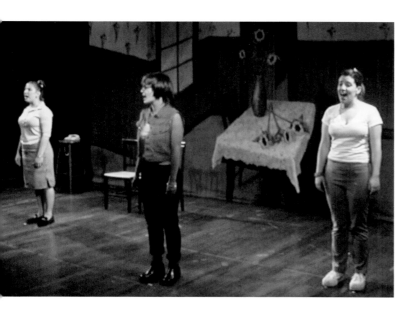

Boxing 2000

Jo-Jo is a janitor. His brother, Freddie, is an unemployed boxer. Marissa is Freddie's girlfriend. Jo-Jo knows Promoter who sets up a fight for them. Promoter talks to them about investing in their future and tells Freddie to stop playing the lotto. Freddie asks Marissa to marry him, but she tells him that she has found something inside of her and she wants him to find that true thing inside himself too. Freddie fights Old Kid Hansen, even though Marissa asks him not to. She leaves. Freddie's father tells him he's not fighting hard enough. Freddie wins. After, he asks Promoter if he fixed the fight. Promoter says no.

Written and Directed by Richard Maxwell

Freddie Robert Torres
Jo-Jo Gary Wilmes
Promoter Chris Sullivan
Marissa Gladys Perez
Old Kid Hansen Jim Fletcher
Referee Lakpa Bhutia
Corner Candido "Pito" Rivera
Afleck Alex Ruiz
Father Benjamin Tejeda

Set and Costumes: Stephanie Nelson
Lights: Eric Dyer
Producer: Barbara Hogue

The Present Company Theatorium
New York 2000

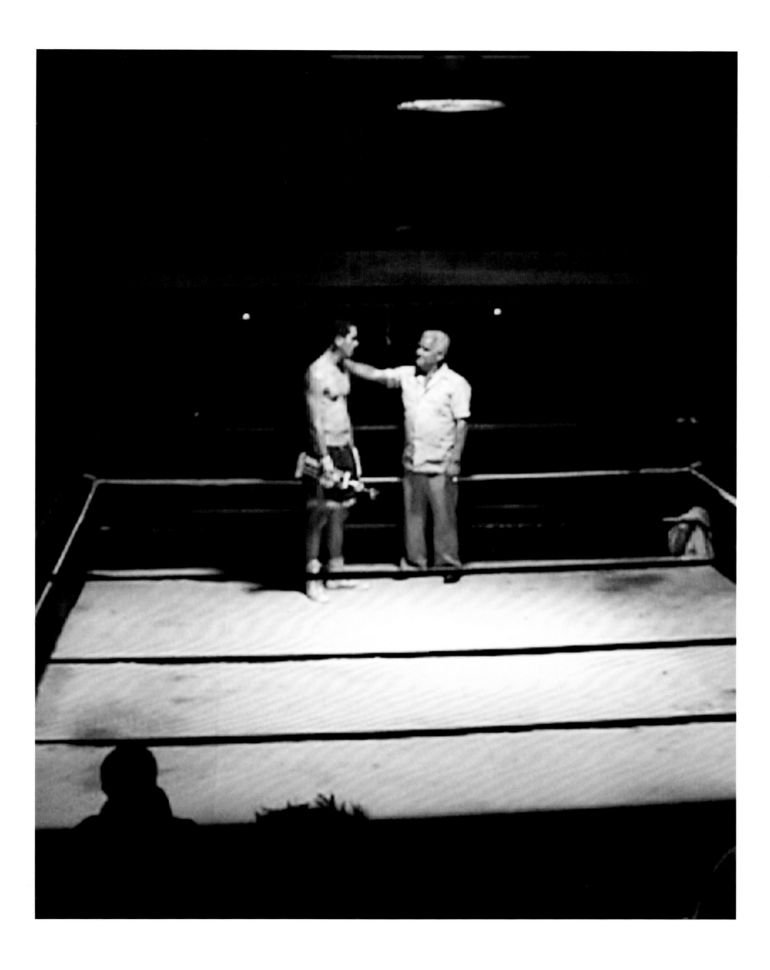

 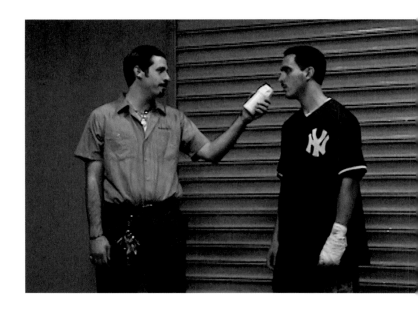

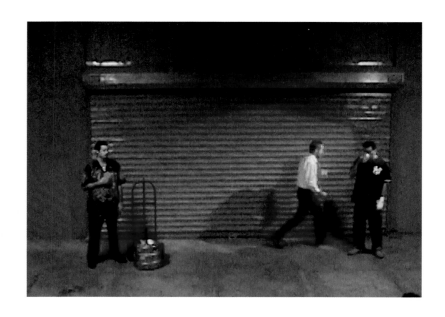 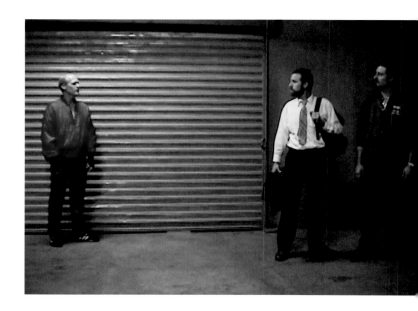

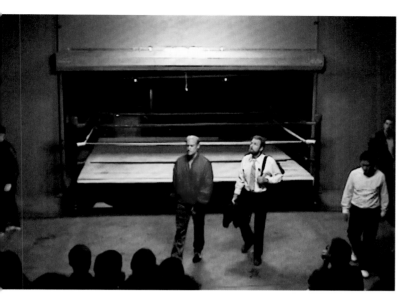
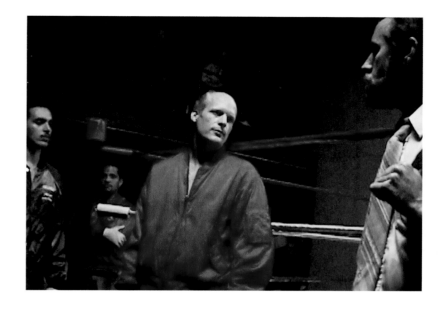
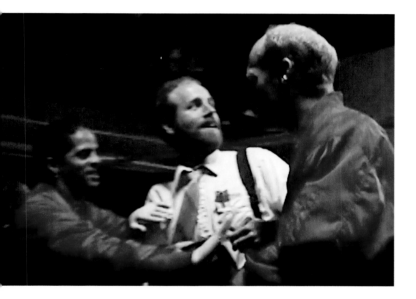
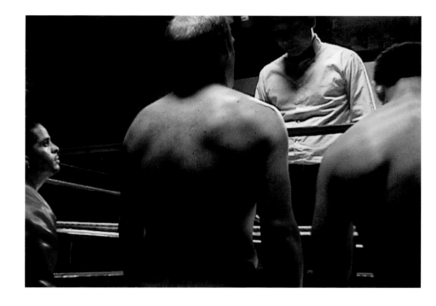
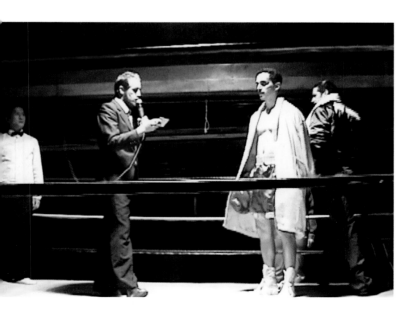
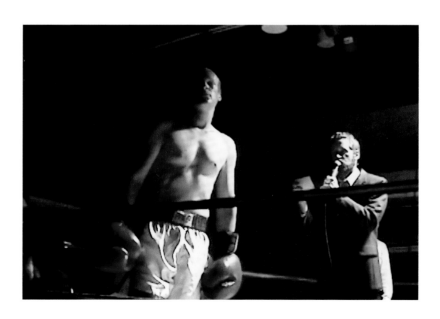

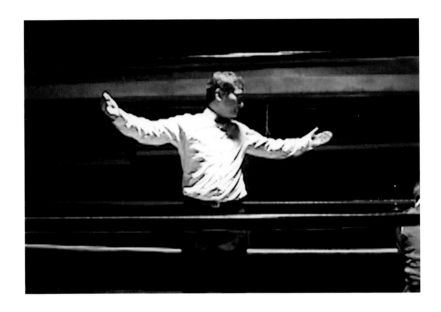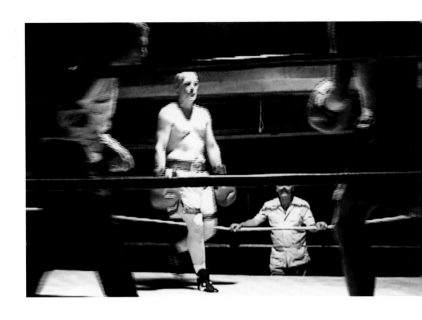

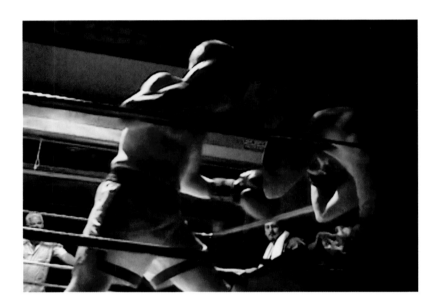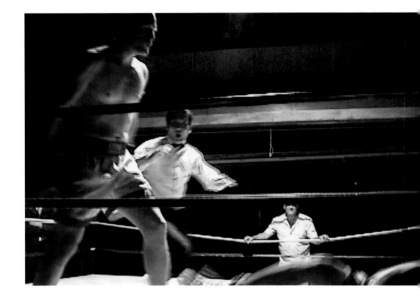

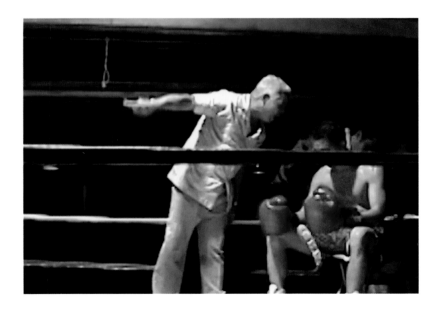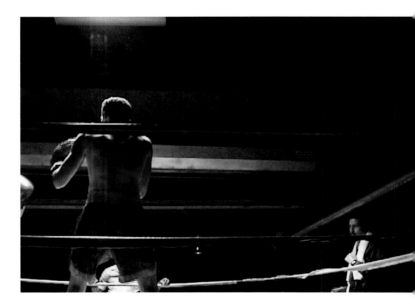

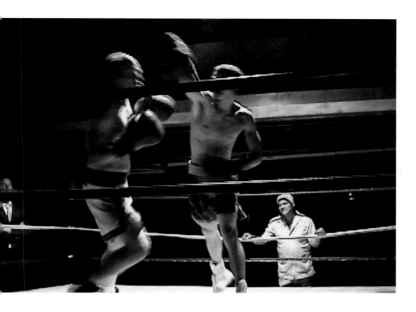 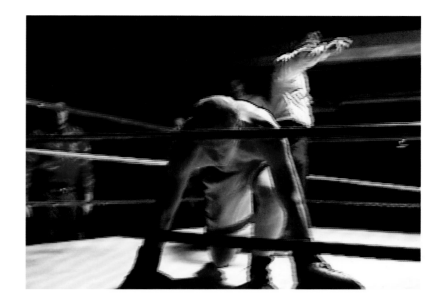

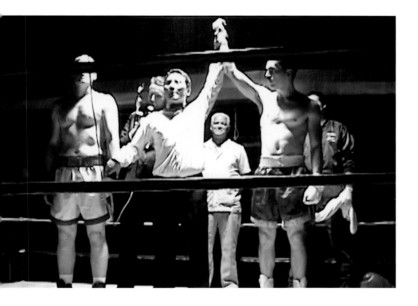 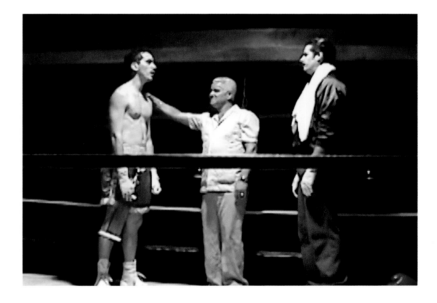

 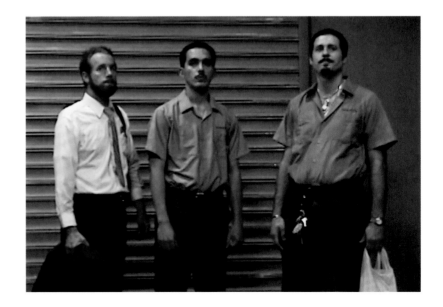

Caveman

A, an employee, comes to visit his boss, C, at home. W lives with C. W warms up microwave food for the men to eat. C speaks crudely to A about women. C and A argue about the methods they use at work; A prefers the new way, and C prefers the old way. They talk about pride. C pulls rank and ends the argument. A tells C that he likes W. W wants to borrow A's car to look for her lost son in San Antonio. A grabs W and kisses her. C and A fight. A picks W up, they fight. A begs W to go with him and says he'll help her find her son. She says she can't. W and C say they love each other. They all sing.

Written and Directed by Richard Maxwell

W Tory Vazquez
C Lakpa Bhutia
A Jim Fletcher

Musicians: Greg Hirte, Bryan Kelly, Scott Sherratt

Set and Costumes: Stephanie Nelson
Lights: Eric Dyer
Producer: Barbara Hogue

Soho Rep.
New York 2001

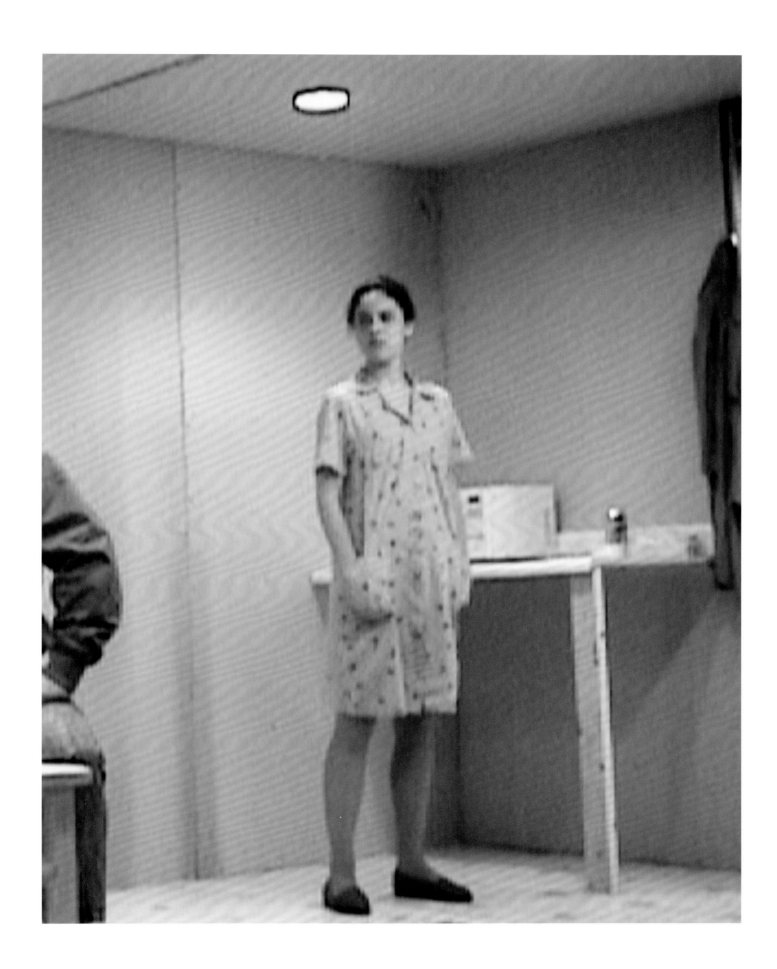

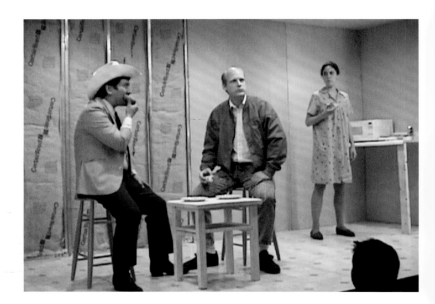

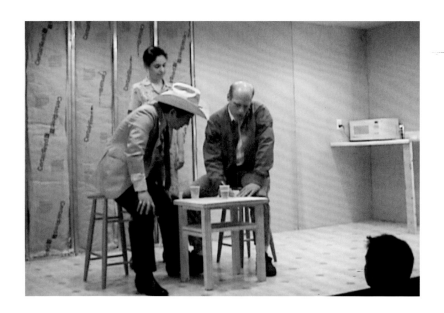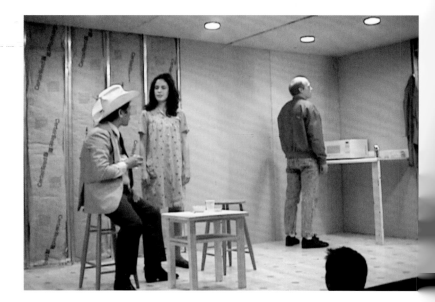

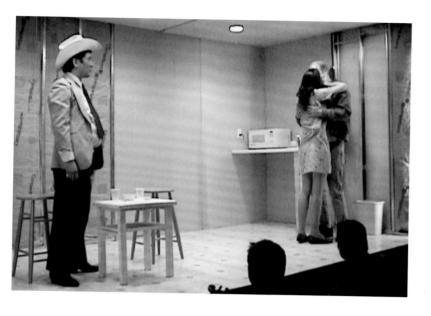 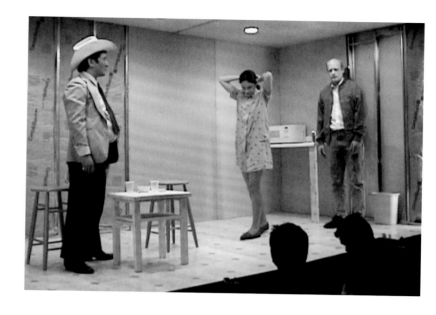

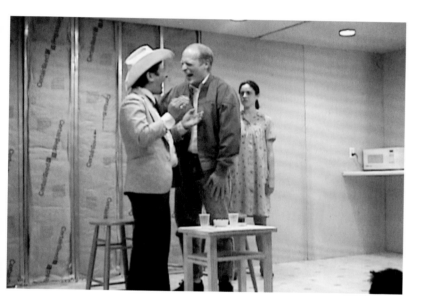 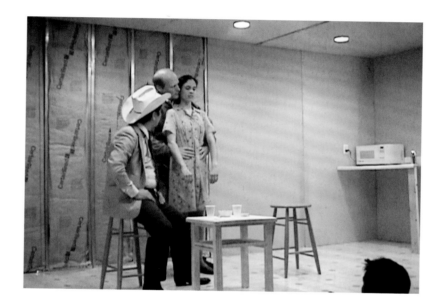

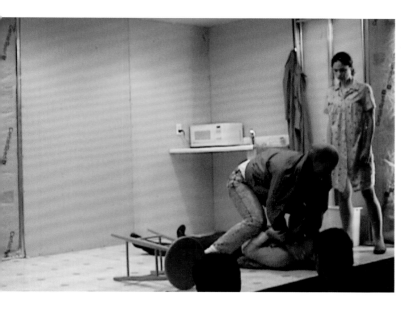
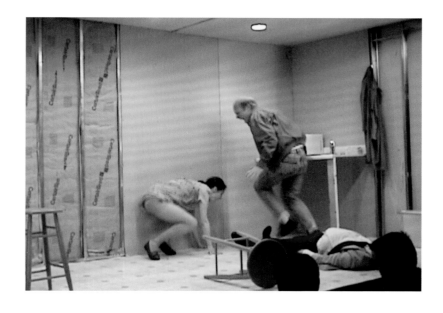
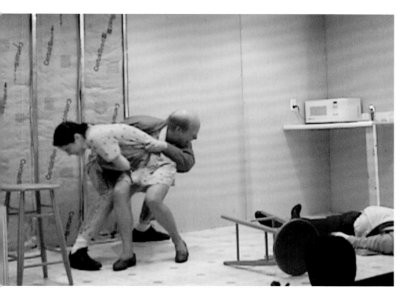

Drummer Wanted

Frank gets hit by a car and breaks his leg. His mom nurses
him back to health. Frank is a rock drummer. His mom plays
piano and sells real estate. They talk about what they want out
of life. Frank has nightmares of his mother abandoning him.
They drive to a karaoke place together. Frank gets drunk and
shares a dubious sea rescue tale. They sing. At home, they
fight. The lawyer calls and tells them Frank will get $150,000
from the insurance company. Frank says he'll finally move out,
but his mom is skeptical. Frank calls her a bitch and she kicks
him out. Frank talks about the consequences of breaking a
vicious circle as he approaches the threshold of the future.

Written and Directed by Richard Maxwell

Mother Ellen LeCompte
Frank Pete Simpson

Set: Angela Moore
Lights: Michael Schmelling
Costumes: Tory Vazquez
Producer: Barbara Hogue

Performance Space 122
New York 2001

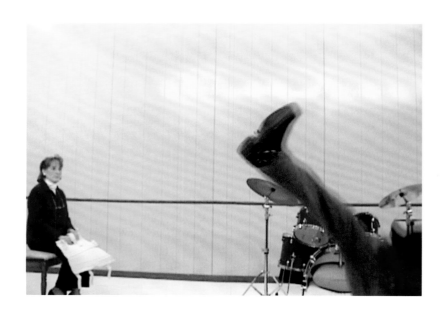 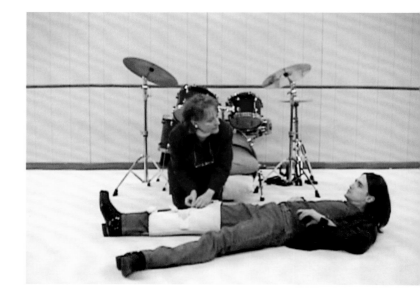

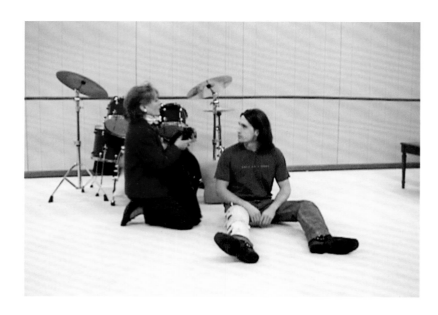

 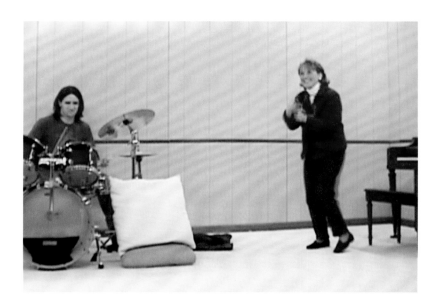

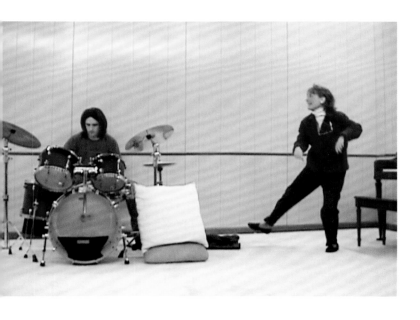

 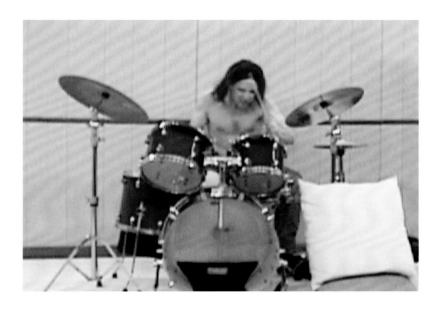

Joe

An eight year-old boy talks about his life. He talks about
Shannon, the girl he likes, and about football, and about trying
to be good, but throwing rocks at people instead. Then he is
18, and tells more about his life, and of Shannon. Then 35,
then 50, then 70. Finally, he is replaced by a robot. The robot
talks about memories from his childhood—asking his mother
for water, seeing his mother lock his coach out of the house
while the coach gets gasoline from the garage. The house is
set on fire. The robot has sex with Shannon, and tells her how
much he loves her.

Written and Directed by Richard Maxwell

Joe Richard Zhuravenko
Joe Matthew Stadelmann
Joe Brian Mendes
Joe Mick Diflo
Joe Gene Wynne
Joe A robot

Musicians: Bob Feldman, Scott Sherratt, Corby Stutzman

Set: Gary Wilmes
Lights: Jane Cox
Costumes: Tory Vazquez
Robot: Joseph Silovsky
Producer: Barbara Hogue

Performance Space 122
New York 2002

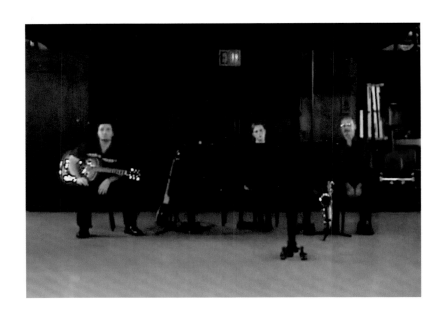 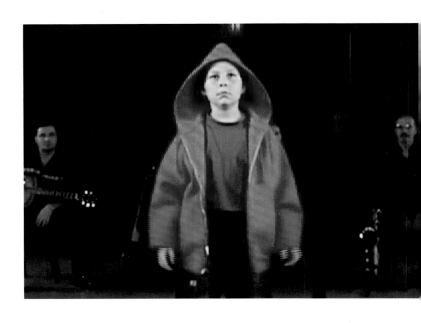

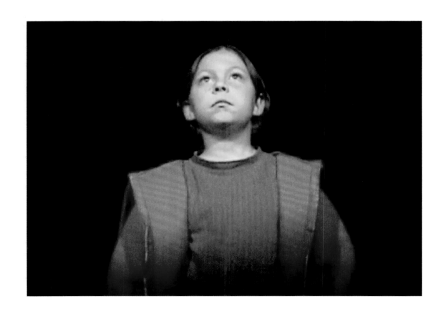 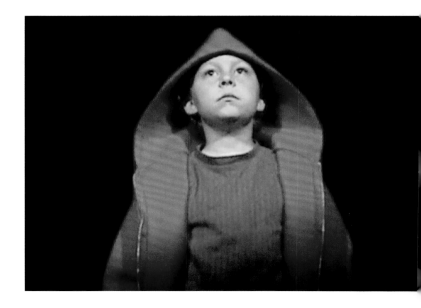

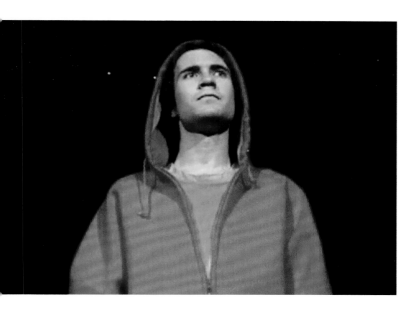

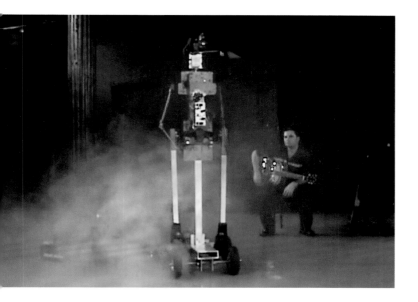

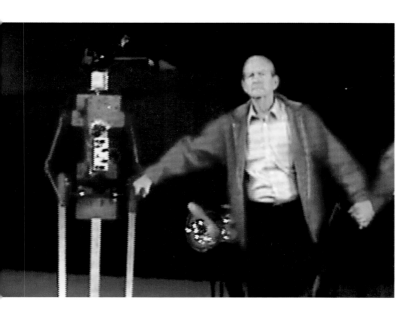

Showcase

Jim, a businessman staying in a hotel, wakes up in bed, talking
to himself. He also addresses his shadow, and anyone else in
the room with them. Gradually getting dressed, he discusses
life on the road, memories, moron jokes, the conference he
is attending, business strategies, and a pivotal deal that went
down recently under intimate circumstances. He sings.

Written and Directed by Richard Maxwell

Jim Jim Fletcher
Shadow Gary Wilmes (later, Bob Feldman)

Producer: Barbara Hogue

Holiday Inn
Cardiff 2003

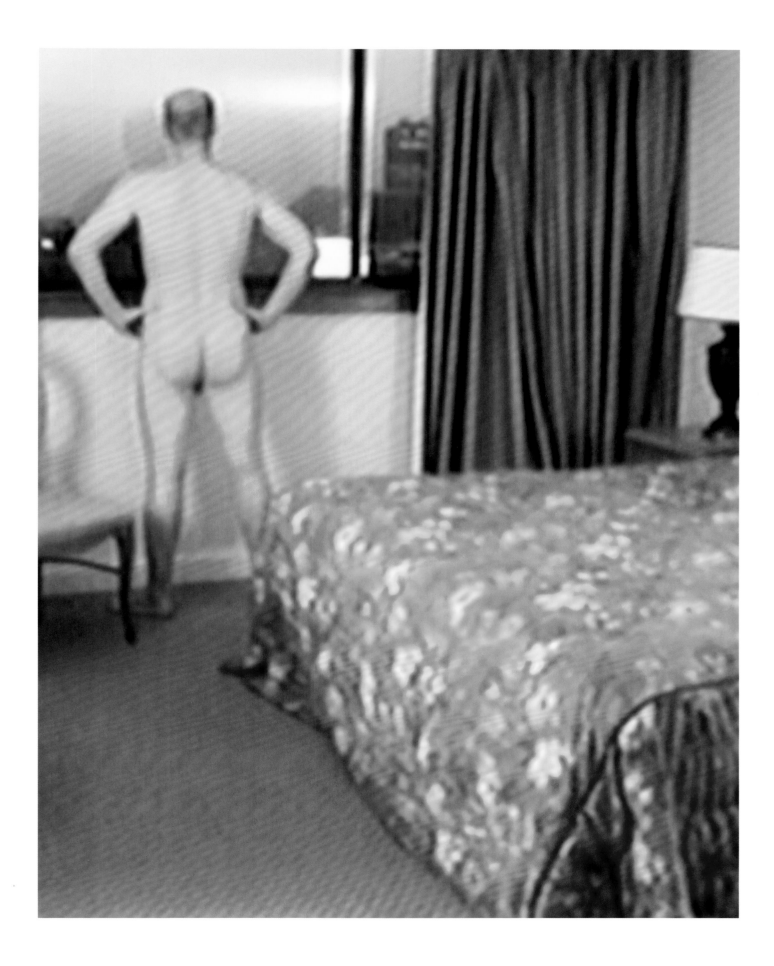

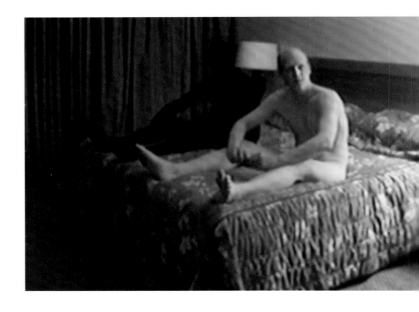
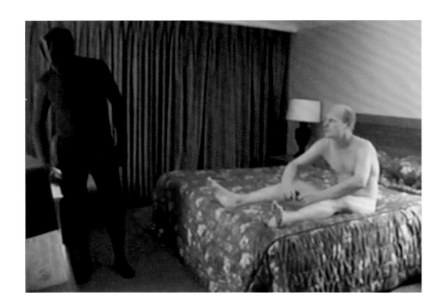
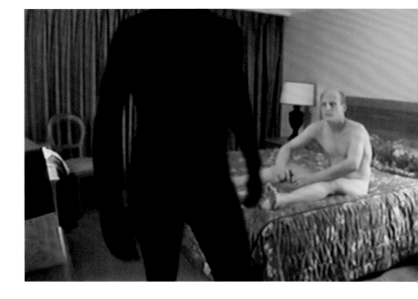
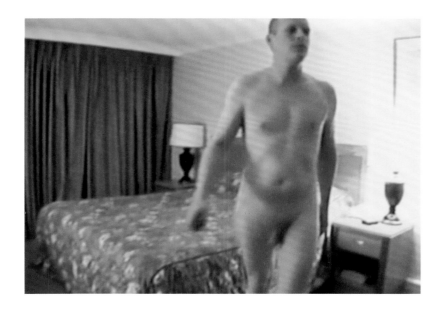

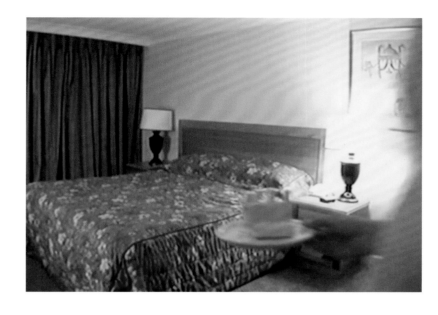
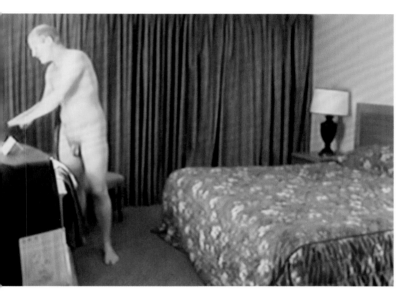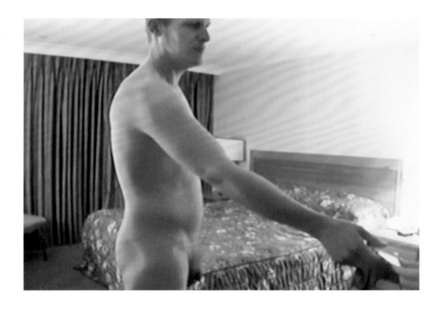
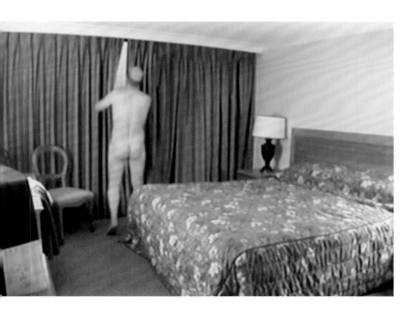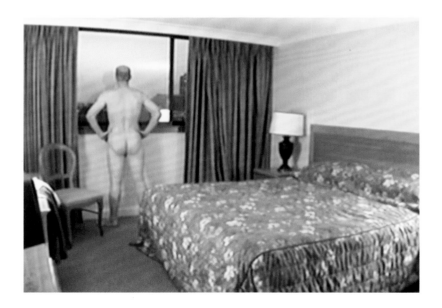

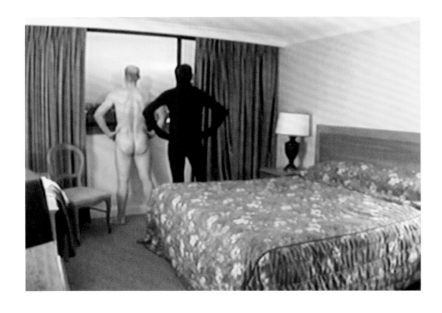
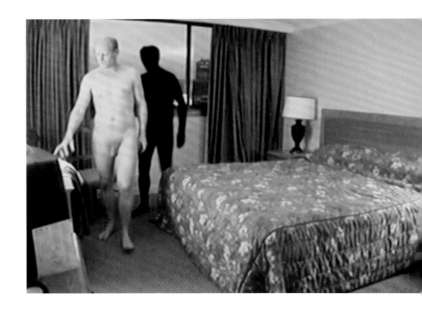
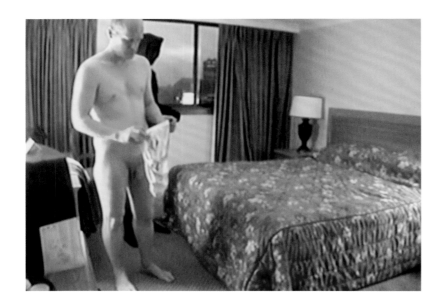
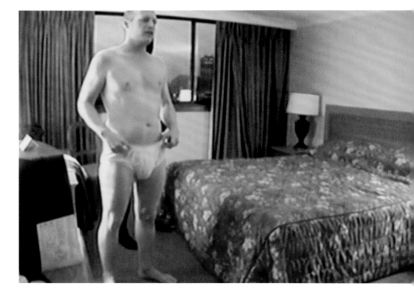
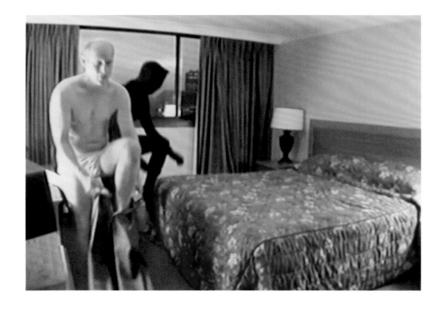
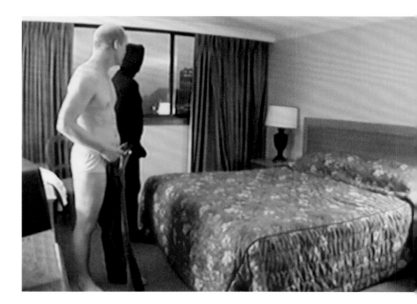

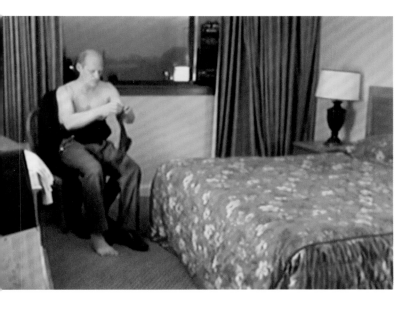 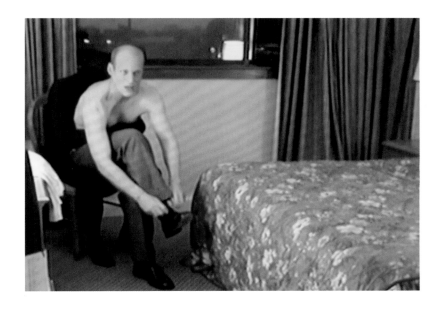

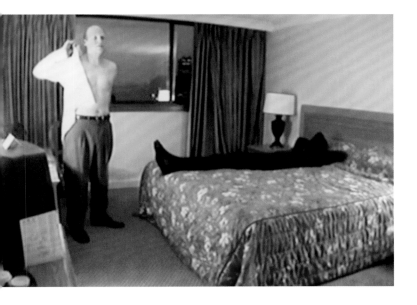 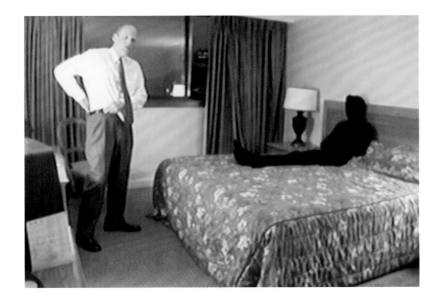

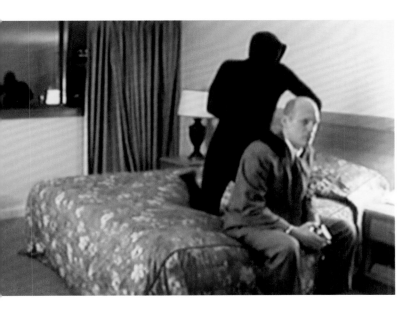 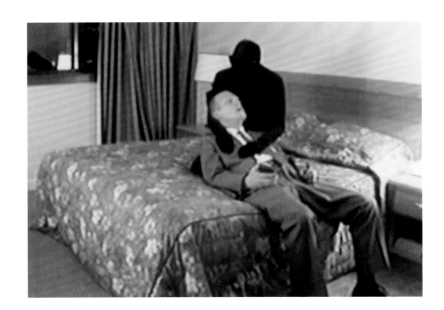

Henry IV, Part 1

Henry Bolingbroke is King. His son, Prince Hal, spends his time drinking and carousing with low companions like his closest friend, Sir John Falstaff. A group of rebels—Henry Percy ("Hotspur"), the Earl of Northumberland, the Earl of Worcester, the Scottish Earl of Douglas, and the Welshman Owen Glendower—rise up against the king. At Shrewsbury, Hotspur leads a vicious attack, though he and the rebels are outnumbered. The Prince makes up with his father and is given high command. He defeats Hotspur, redeeming himself from his former dissolution and proving himself a great warrior and future king. In an act of kingly mercy, Hal releases his prisoner, the valiant Earl of Douglas, without ransom. But the war is not over; Northumberland, Mortimer, and Glendower join with the Archbishop of York and continue their rebellion.

Written by William Shakespeare
Directed by Richard Maxwell

King Henry the Fourth Jim Fletcher
Earl of Westmoreland Jimmie James
Henry, Prince of Wales Gardiner Comfort
Sir John Falstaff Gary Wilmes
Ned Poins Matthew Stadelmann
Thomas Percy, Earl of Westmoreland Michael Pisacane
Henry Percy, Earl of Northumberland Paul Viani
Henry Percy (Hotspur) Brian Mendes
Sir Walter Blunt Bob Feldman
Gadshill Roger Babb
Bardolf Benjamin Tejada
Peto Candido "Pito" Rivera
Lady Percy (Kate) Kate Gleason
Hostess (Mistress Quickly) Vicki Walden
Servant Richard Zhuravenko
Servant #2 Frankie Lombardi
Sheriff Alex Delinois
Edmund Mortimer, Earl of March Peter Guarino
Owen Glendower Lapka Bhutia
Lady Mortimer Aimee Lutkin
Sir Richard Vernon Lamar Proctor
Archibald, Earl of Douglas Scott Sherratt
Prince John of Lancaster Austin Torelli
Travelers Rob Marcato, Jeremy Lydic

Set: Stephanie Nelson
Lights: Jane Cox
Costumes: Kaye Voyce
Producer: Barbara Hogue

Brooklyn Academy of Music
New York 2003

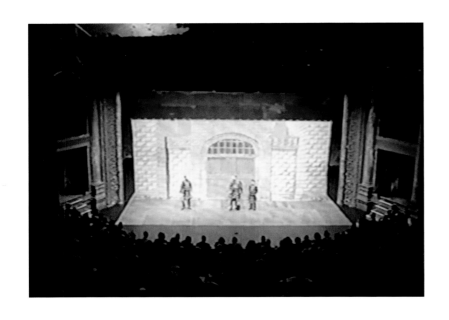
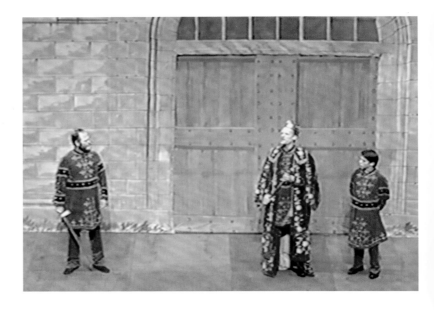
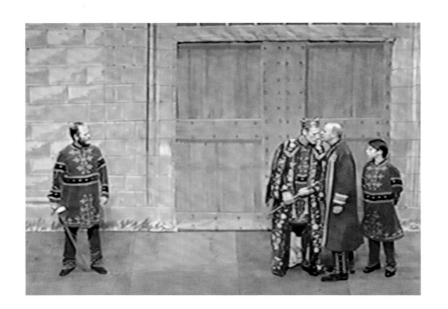
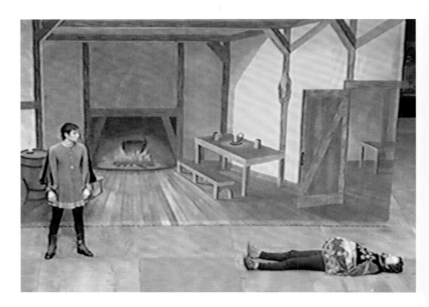

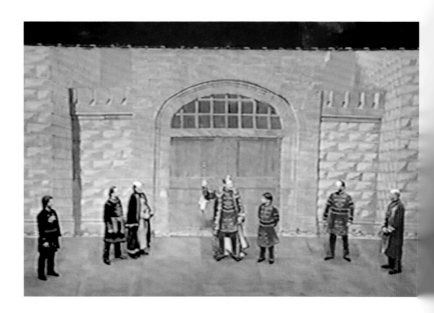

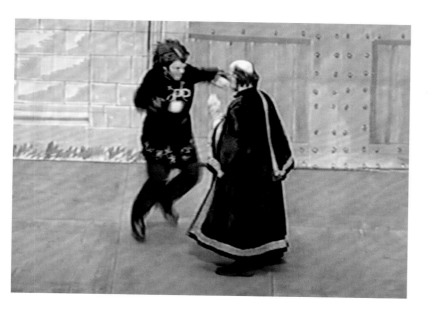

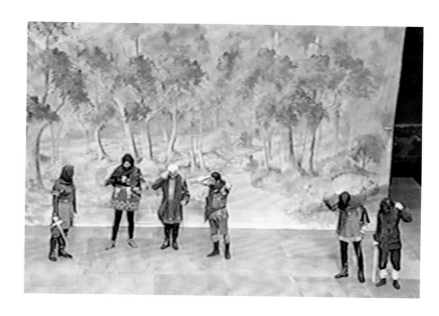
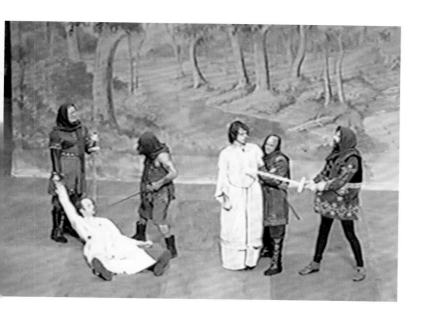

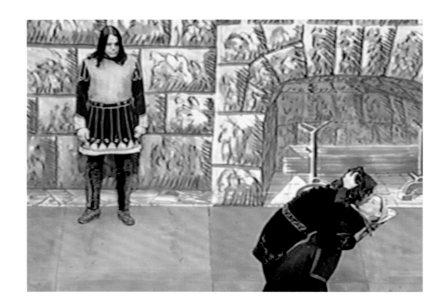
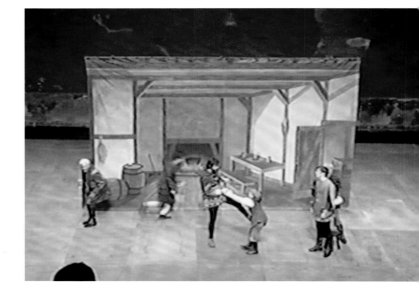

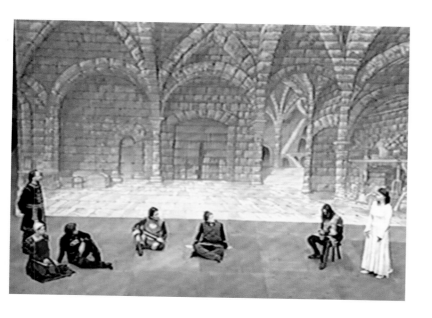
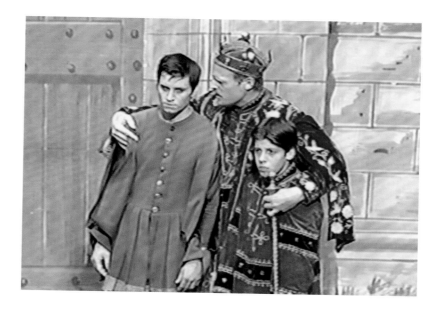
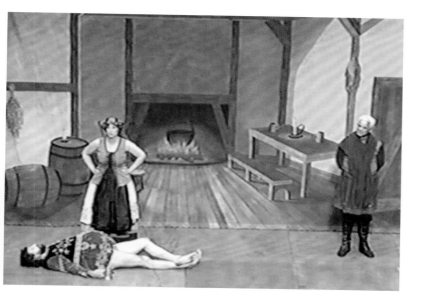
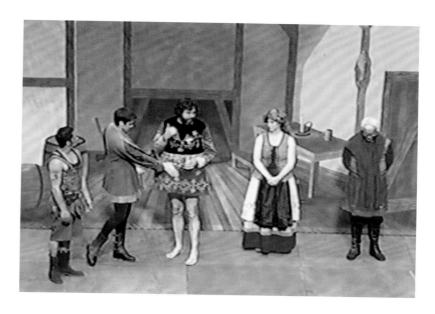

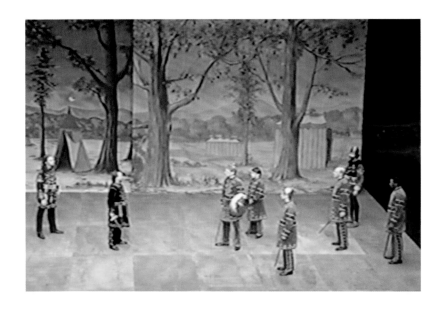

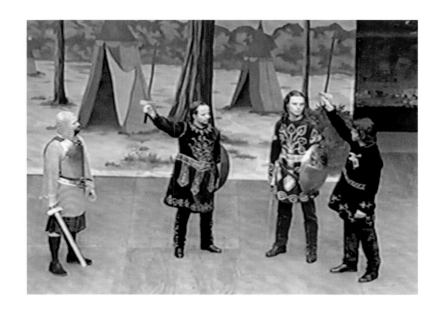
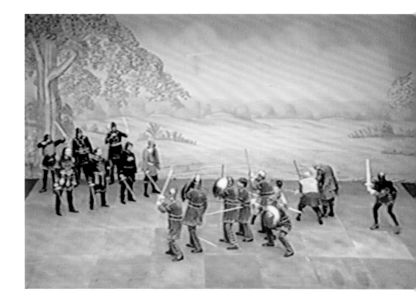

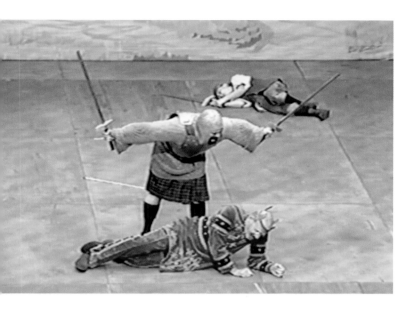 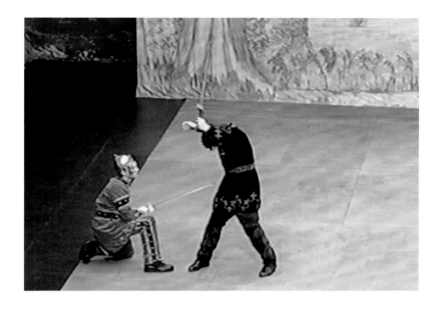

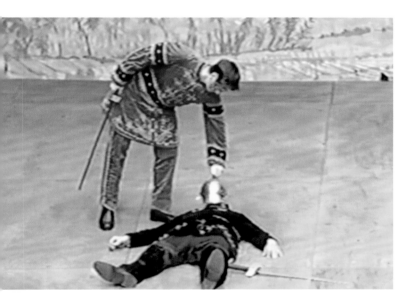 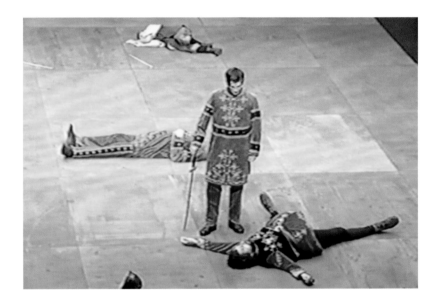

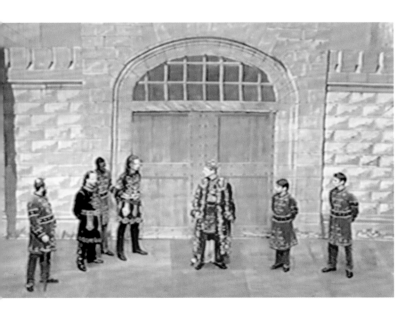 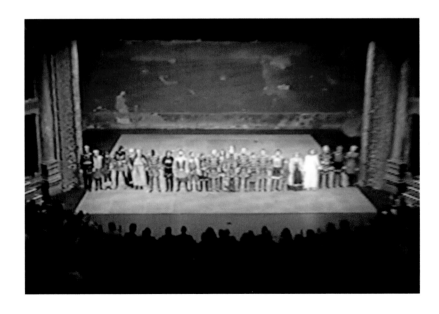

Good Samaritans

Rosemary is an intake counselor in a rehab center. Kevin is
her patient, sent in lieu of jail time. Rosemary believes in
charity; Kevin believes in his ability and doesn't want to do
any of the jobs she assigns him. They have sex and fall in love.
Kevin leaves to pursue enjoyment and indulgence. Rosemary
grieves. Kevin returns, briefly, then leaves again.

Written and Directed by Richard Maxwell

Rosemary Rosemary Allen
Kevin Kevin Hurley
Bob Bob Feldman

Musicians: Catherine McRae, Scott Sherratt

Set, Lights, and Costumes: Stephanie Nelson
Producer: Barbara Hogue

St. Ann's Warehouse
Brooklyn 2004

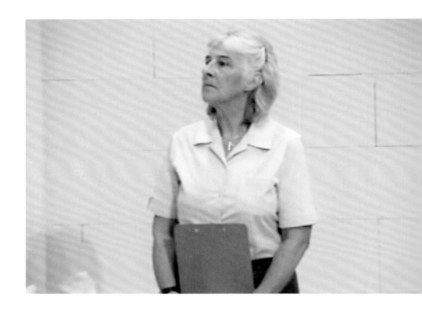

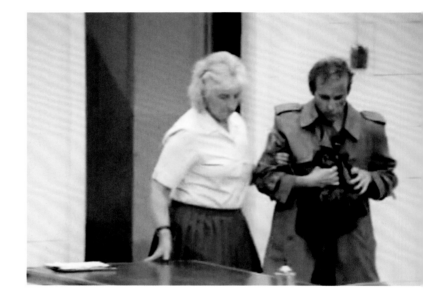
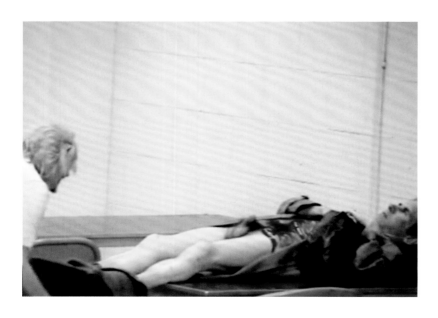

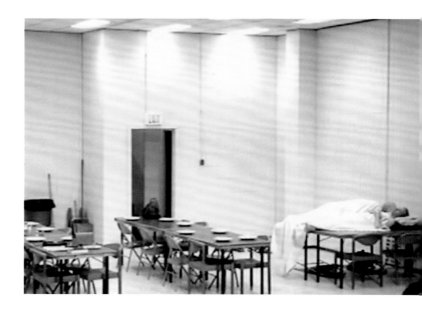

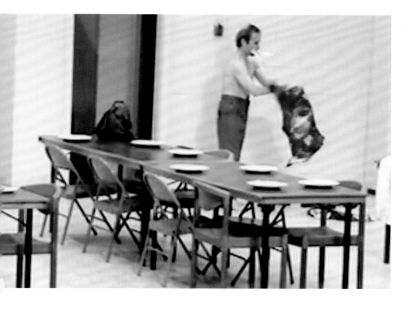
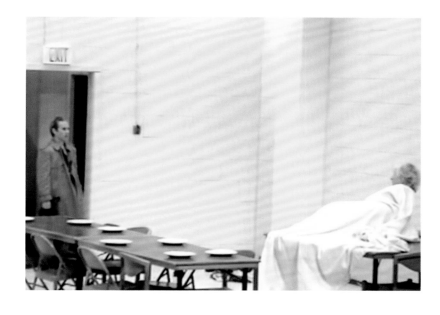

The End of Reality

Tom (1), Brian (2), and Jake (4) are security guards. Shannon
(6) applies, is hired, but freezes when a man (3) comes in and
abducts Jake. Shannon quits. Tom's goddaughter, Marcia (5)
is hired to replace her. The man comes in again and this time
they apprehend him. Marcia lives with Tom and he worries
about her. He asks Brian if she can stay with him. Brian and
Marcia talk; she thinks Tom is living a drugged half-existence.
Marcia has trouble with her family. In the presence of the
captured man, Marcia talks about belief and God and readiness
and goodness. Then she lets the man go. Later the man comes
back and beats Brian up. Brian confesses his love for Marcia
but she says she can't. Tom discovers that Marcia let the man
go and fires her. Brian begs him to bring her back. Tom tells
him that they share the same bed, and Brian leaves. Shannon
comes back to get her paycheck. The man and Jake come in
and beat on Tom and gouge Shannon's eyes out. Tom speaks
of Judgment Day.

Written and Directed by Richard Maxwell

1 Thomas Bradshaw
2 Brian Mendes
3 James Fletcher
4 Alex Delinois
5 Marcia Hidalgo
6 Sibyl Kempson

Set and Lights: Eric Dyer
Costumes: Kaye Voyce
Producer: Barbara Hogue

The Kitchen
New York 2006

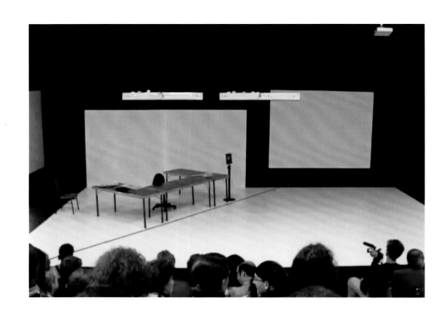

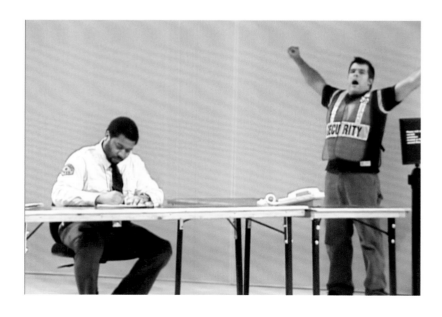
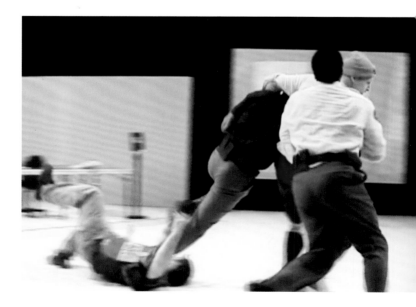

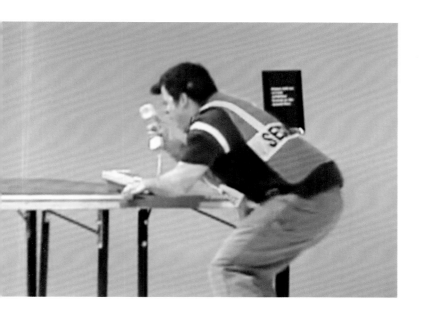
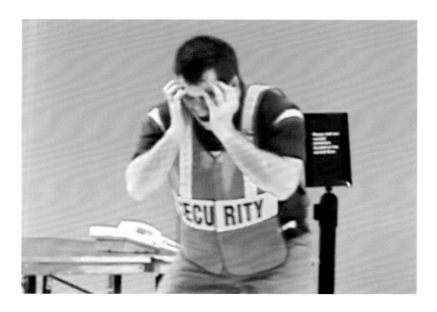

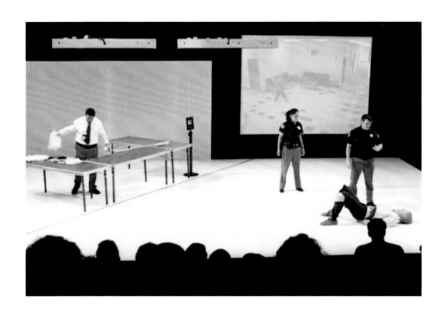

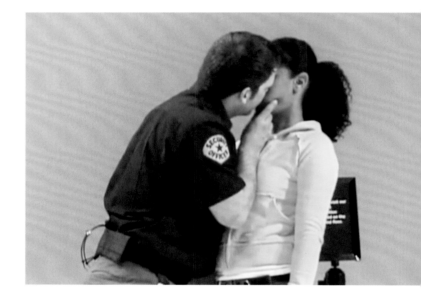

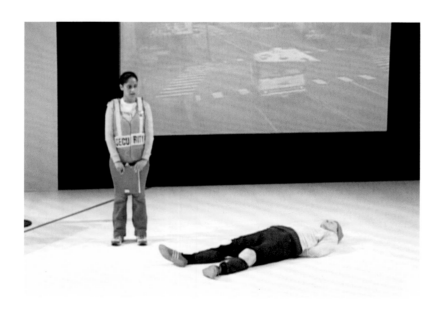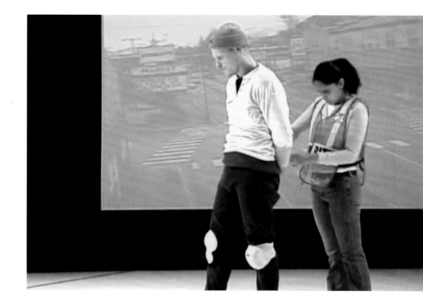

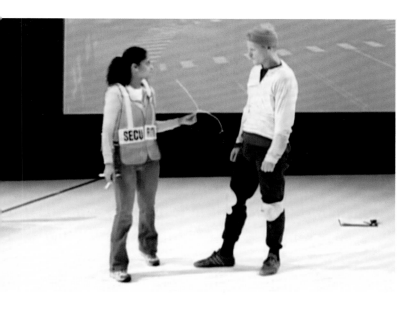
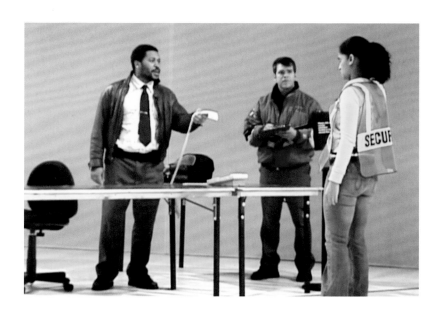
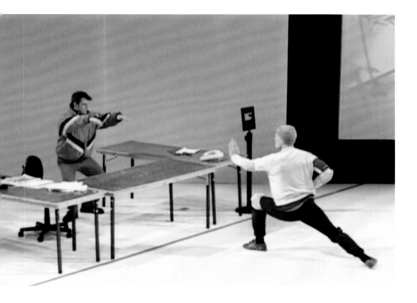

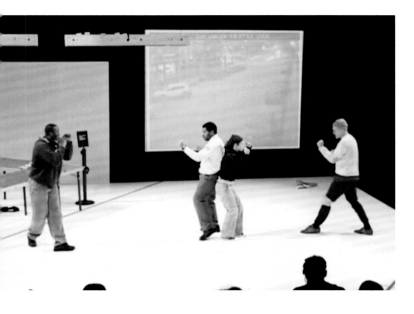

Ode to the Man Who Kneels

There is Standing Man and Kneeling Man. Kneeling Man is an
actor. He speaks of storing up his feelings, his broken heart,
of pain and of death. Standing Man shoots him. In the town
called Grid, Standing Man meets Dashing Man, whom he pays
to make a daguerreotype of him and to gather riders. When
the riders don't come on time, Standing Man kills Dashing
Man. Standing Man courts Waiting Woman. He tells her he
has raped, but they choose each other and make a life. Then
a younger woman, Juny, comes to Grid to claim her father's
land. Waiting Woman advises Juny and pleads with her to stay
and keep her company. Juny takes a walk and finds Standing
Man. They make love, and a life together; he builds her a
citadel. Waiting Woman enters from the sky, leading the Great
Hunt, followed by Woden's riders. She takes Juny to the sky.
Standing Man is left alone.

Written and Directed by Richard Maxwell

Standing Man Jim Fletcher
Kneeling Man Greg Mehrten
Waiting Woman Anna Kohler
Dashing Man Brian Mendes
Juny Emily McDonnell

Musicians: Mike Iveson, Richard Maxwell

Set and Lights: Sascha van Riel
Costumes: Tory Vazquez
Company Manager: Nicholas Elliott

The Performing Garage
New York 2007

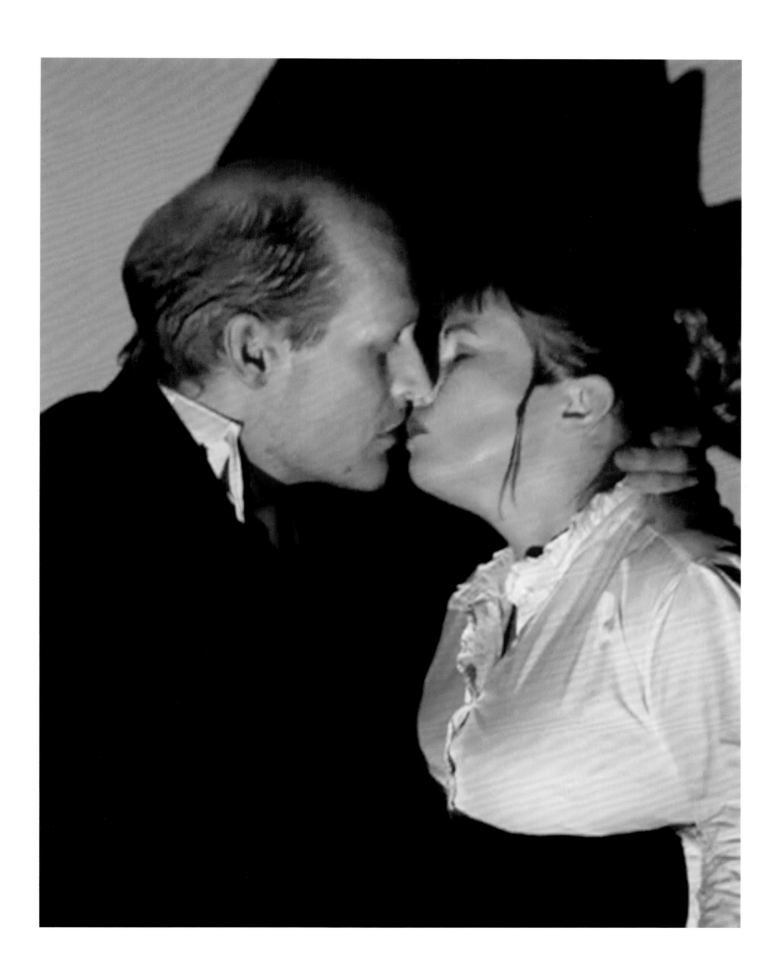

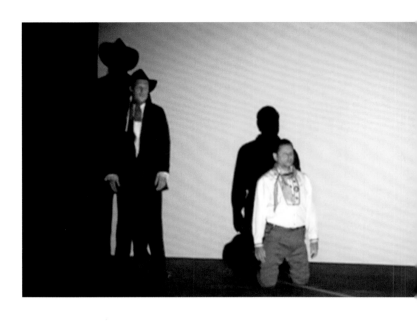

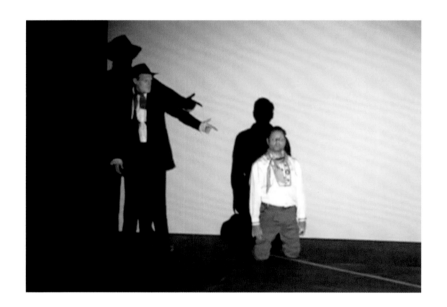

 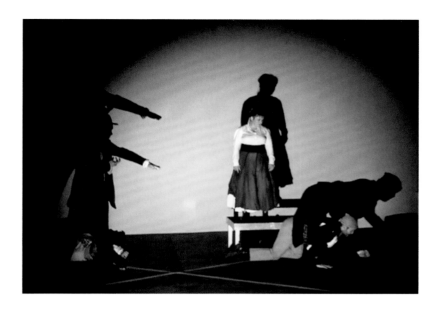

 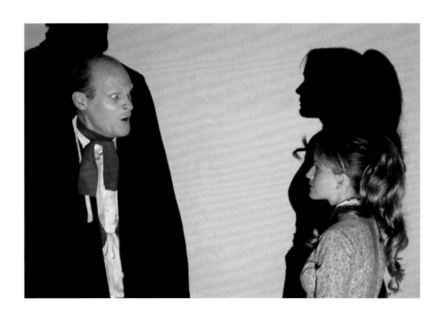

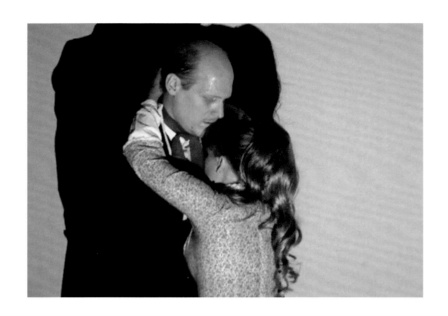

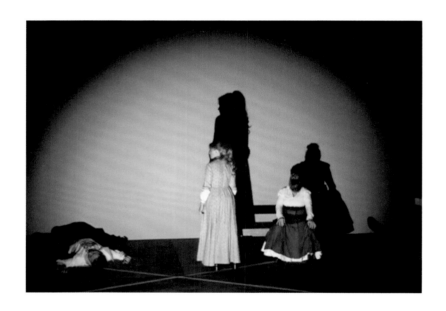
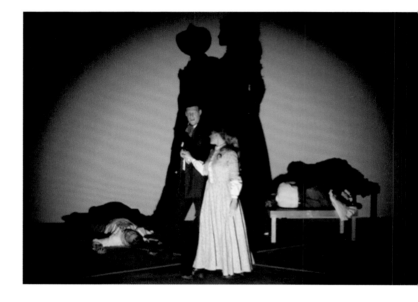
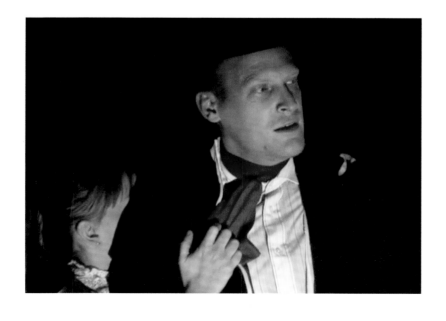
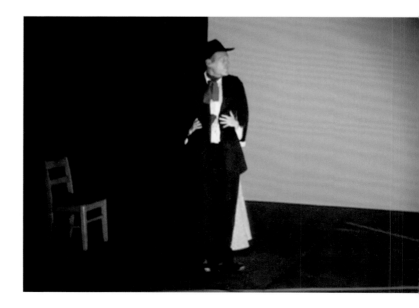

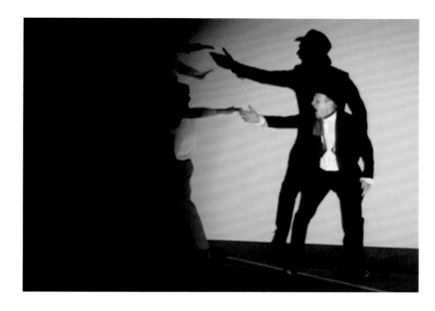
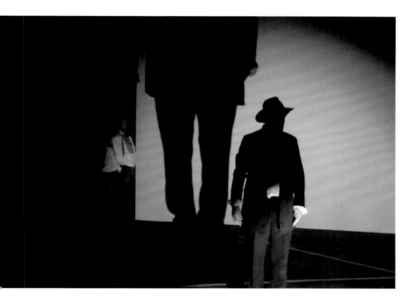
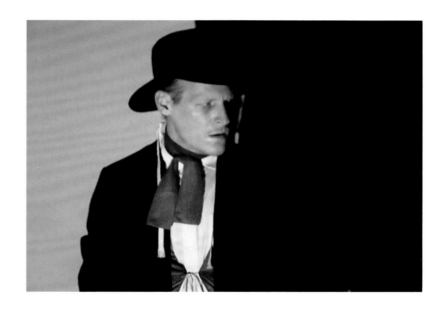
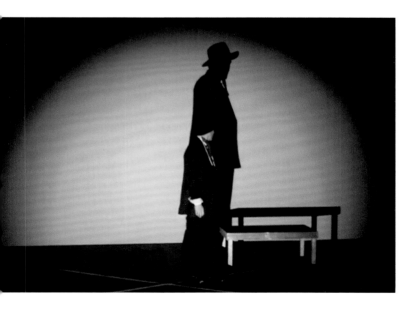
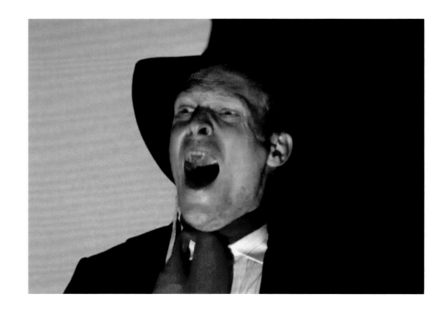

People Without History

In the year 1403, at the border of England and Wales, Alice
forages for food. After the battle of Shrewsbury, Owain,
a Welsh soldier, takes Blunt as his prisoner. Meanwhile,
Mendace and Rhobert march another prisoner, Sheriff, to
prison. At the prison, all the men are hungry and can hardly
remember. Then Alice feeds them. Mendace and Sheriff
talk about Woman, and the comfort she offers, and the
inspiration. Alice talks about the difficulty of trying to heal
the men with nothing, men who have forgotten their pasts
and want to remember. She talks about absolving them of
this desire and the pain of seeing them begin again. Alice
and Rhobert find an understanding. Mendace tells Alice
they will rape her. Alice tells the men that she has loved a
woman. Alice calls herself the last woman on Earth. Owain
and Blunt are alone on the road again. They talk about
Amelia, a woman whose body Blunt once loved. They talk
about the fear and sadness of having left their lives behind
and the beauty of the landscape.

Written by Richard Maxwell
Directed by Brian Mendes

Alice Tory Vazquez
Owain Tom King
Blunt Bob Feldman
Mendace Pete Simpson
Rhobert Jim Fletcher
Sherrif Alex Delinois
Anonymous Rafael Sánchez

Set and Costumes: Lara Furniss
Company Manager: Nicholas Elliott

The Performing Garage
New York 2009

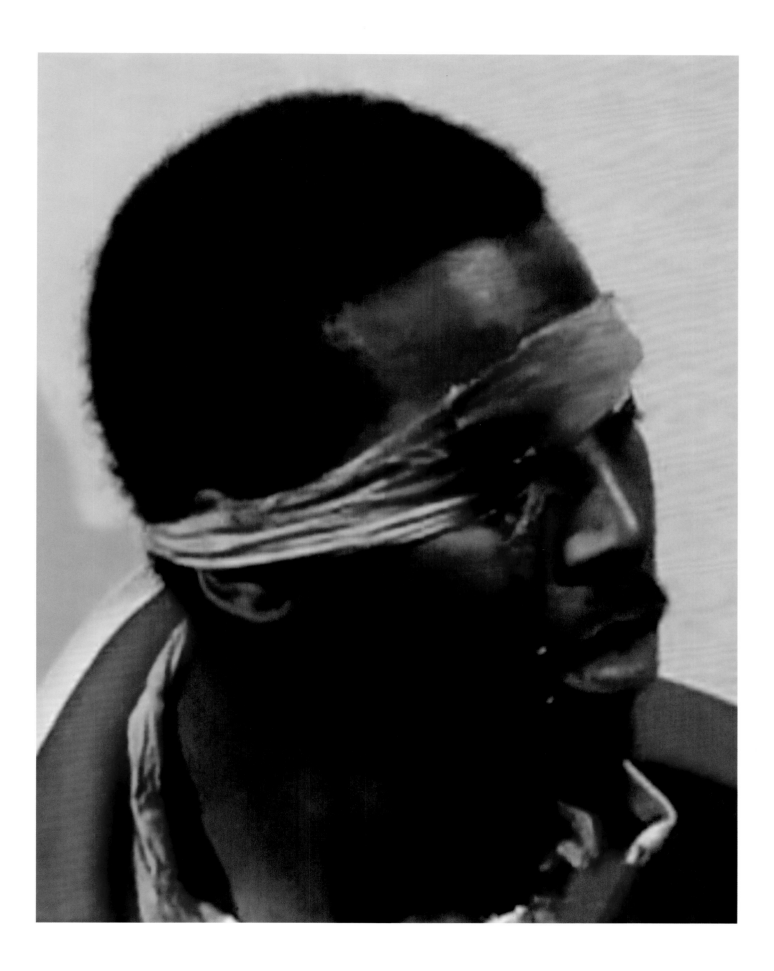

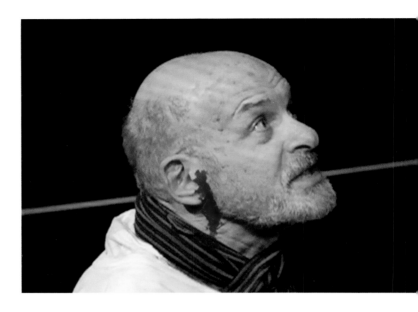

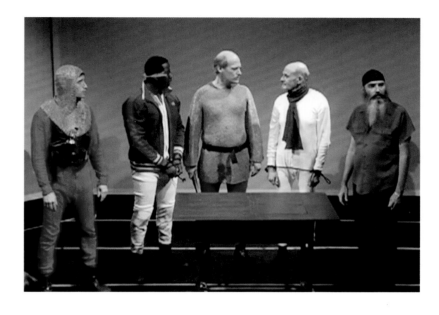

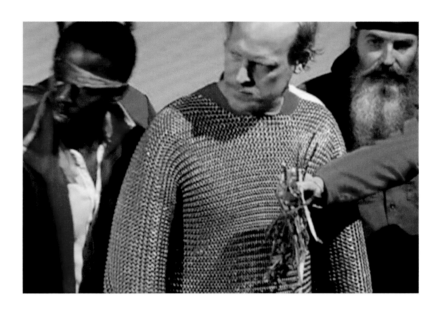

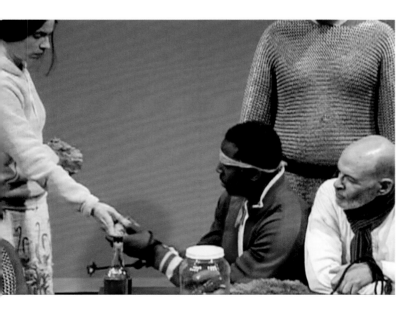
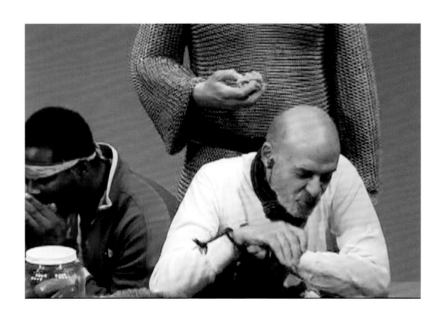

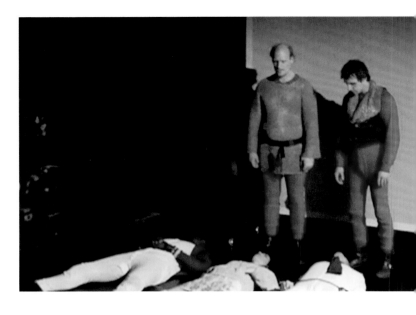
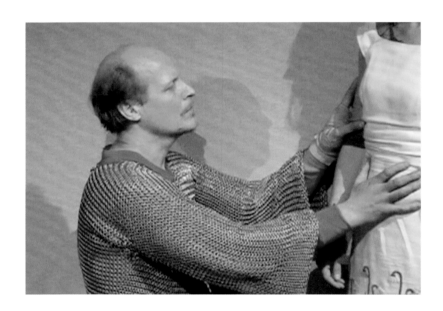

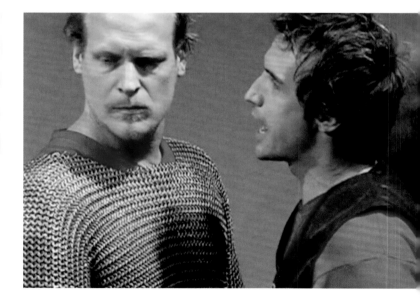

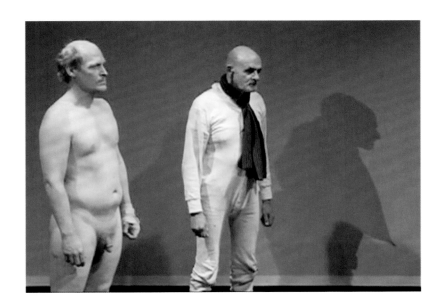
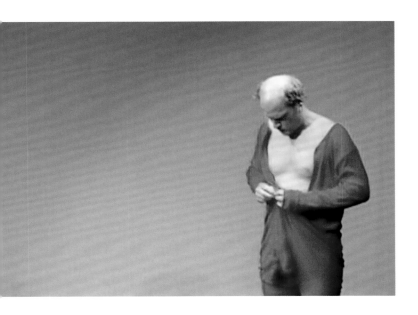
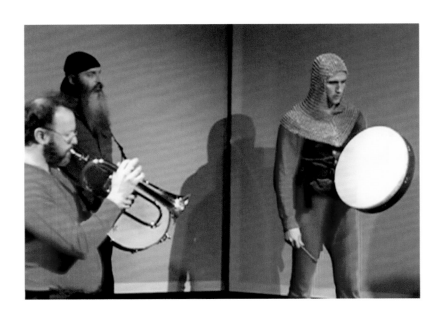

Ads

Invitees write down and share their beliefs on video. Their life-sized recorded images are projected onto glass in front of a live audience.

Conceived and Directed by Richard Maxwell

New York Participants: Ramin Bahrani, Lakpa Bhutia, Jerimee Bloemeke, Sophia Chai, Janet Coleman, Keith Connolly, Ginger Corker, Richard Dundy, Bob Feldman, Rosie Goldensohn, Anita Hollander, Rosalie Ann Kaplan, Lou Kuhlmann, Michelle A. Lee, Walid Mohanna, Philip Moore, Farooq Muhammad, Nicole Colon, Christian Nunez, Louis Puopolo, Mark Russell, Katherine Ryan, Rafael Sánchez, Mónica de la Torre, Ariana Smart Truman, Kate Valk

Director of Photography: Michael Schmelling
Production: Bozkurt Karasu
Company Manager / Script Supervisor: Nicholas Elliott

Performance Space 122
New York 2010

Neutral Hero

In a town at the intersection of two highways, an anonymous
boy grows up. Many people describe the town and its stores
and its history. In the home, the father leaves. The boy gets
older and tries different jobs. He meets a girl he likes. He
leaves town. The hero is attacked by a man in a mask and his
companion. He wants to know where his father is. He falls in
love and falls out of love. He finds his dead grandmother and
she tells him his father is alive but an unhappy man because he
never accepted his life. She tells the hero to remain desirable
and to endure any punishment. The hero and his father try to
reconcile, but the hero finds it hard to speak. The father comes
back to the mother. To explain what happened in his absence,
he describes being in the woods and watching a dance at a
summer camp, going into the girls' cabin, and then being hung
from a tree by a bunch of men. The mother talks about her
son's dissatisfaction. She thanks everyone for listening.

Written and Directed by Richard Maxwell

James Moore
Andie Springer
Keith Connolly
Bob Feldman
Janet Coleman
Alex Delinois
Philip Moore
Paige Martin
Lakpa Bhutia
Andrew Weisell
Jean Ann Garrish
Rosie Goldensohn

Set and Lights: Sascha van Riel
Costumes: Kaye Voyce
Company Manager: Nicholas Elliott

Project Arts Centre
Dublin 2013

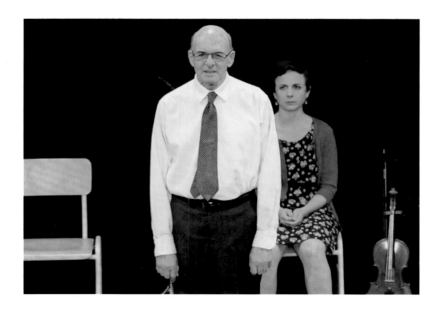
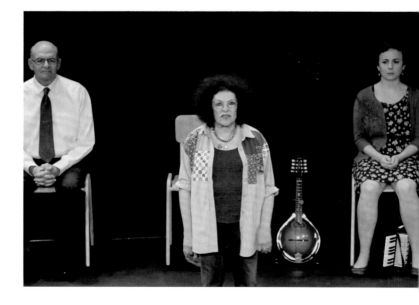

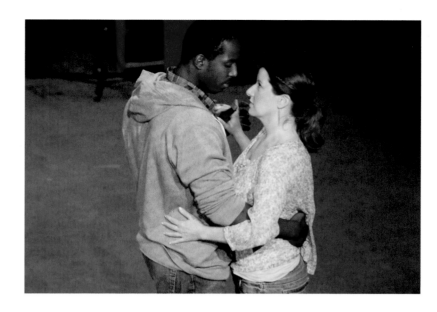

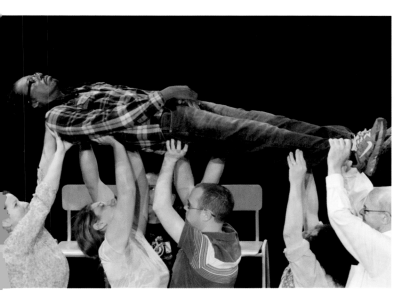
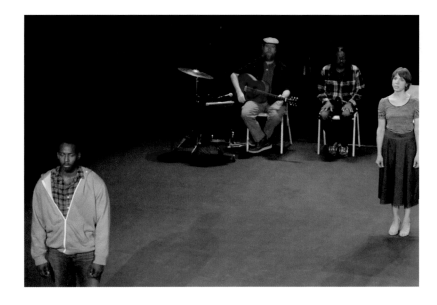
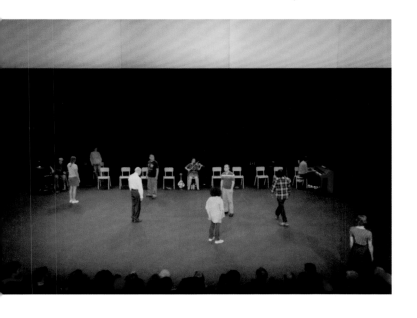

Open Rehearsal

Linda, Sheena, Dr. Weissplatz, and Eleanor live in Salem.
They are settlers; they struggle to be good. Dr. Weissplatz
heals the children from illness. Linda buys Sheena a dress.
Eleanor helps the doctor though she is a witch. Sheena likes to
sing hymns. They plan a pageant. Linda and the doctor have an
affair. At the pageant, Munoz Teddy appears, Linda's former
lover. At the town meeting, Eleanor accuses Linda of adultery.
There is a trial. Linda is judged. An effigy is burned.

Written and Directed by Richard Maxwell

Linda Linda Mancini
Sheena Sheena See
Dr. Weissplatz Roy Faudree
Eleanor Eleanor Hutchins
Munoz Teddy Brian Mendes

Musician Tom King

Set and Lights: Sascha van Riel
Costumes: Kaye Voyce
Company Manager: Nicholas Elliott

Whitney Museum of American Art
New York 2012

*For the 2012 Whitney Biennial, New York City Players
publicly rehearsed a play on the museum's fourth floor.*

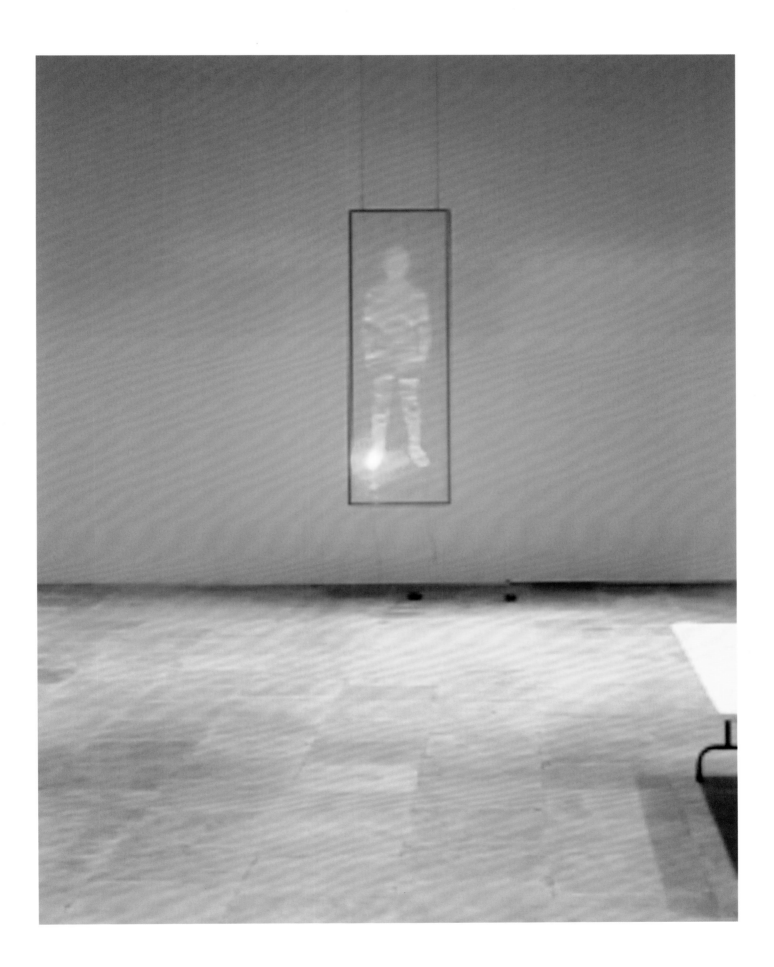

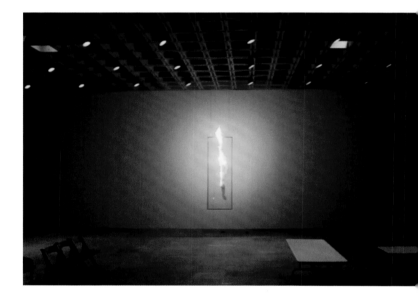
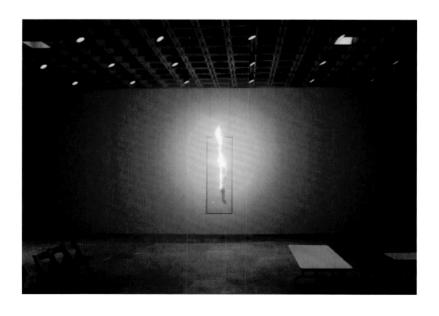
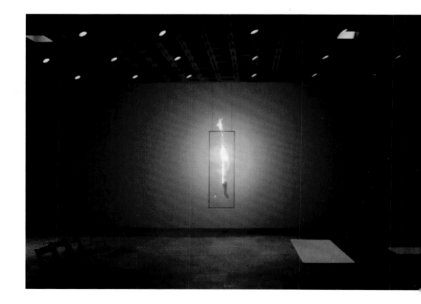

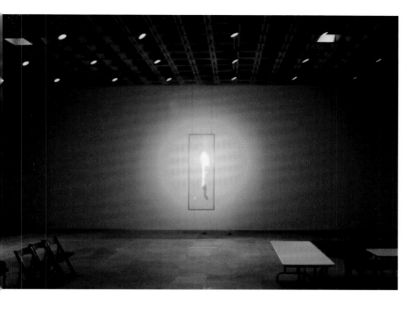

Isolde

Isolde is an actress. Her husband, Patrick, is a contractor.
They hire an award-winning architect, Massimo, to build
Isolde a lake house. There is something wrong with Isolde's
memory. She tries to describe to Massimo the house she
wants, then Massimo presents his idea. Isolde and Massimo
have an affair. Patrick tells his friend, Uncle Jerry, that he's
letting her do it. Patrick and Massimo clash over the plans
for the house. The construction isn't progressing. Patrick
challenges Massimo to draw the plans; Massimo refuses. In a
dumb-show, the actors playing Patrick, Isolde, Massimo, and
Uncle Jerry mime the story of Tristan and Isolde, after which
Isolde tries to deliver her lines and fails. She disappears.
On the opposite side of the lake, Uncle Jerry gives Massimo
an envelope of money and tells him that Patrick and Isolde
no longer require his services. Uncle Jerry tells Massimo he
considered getting rid of him but decided not to; Uncle Jerry
talks about loneliness.

Written and Directed by Richard Maxwell

Isolde Tory Vazquez
Patrick Jim Fletcher
Massimo Gary Wilmes
Uncle Jerry Brian Mendes

Set and Lights: Sascha van Riel
Costumes: Romy Springsguth
Additional Costumes: Kaye Voyce
Producing Manager: Katherine Brook

Abrons Arts Center
New York 2014

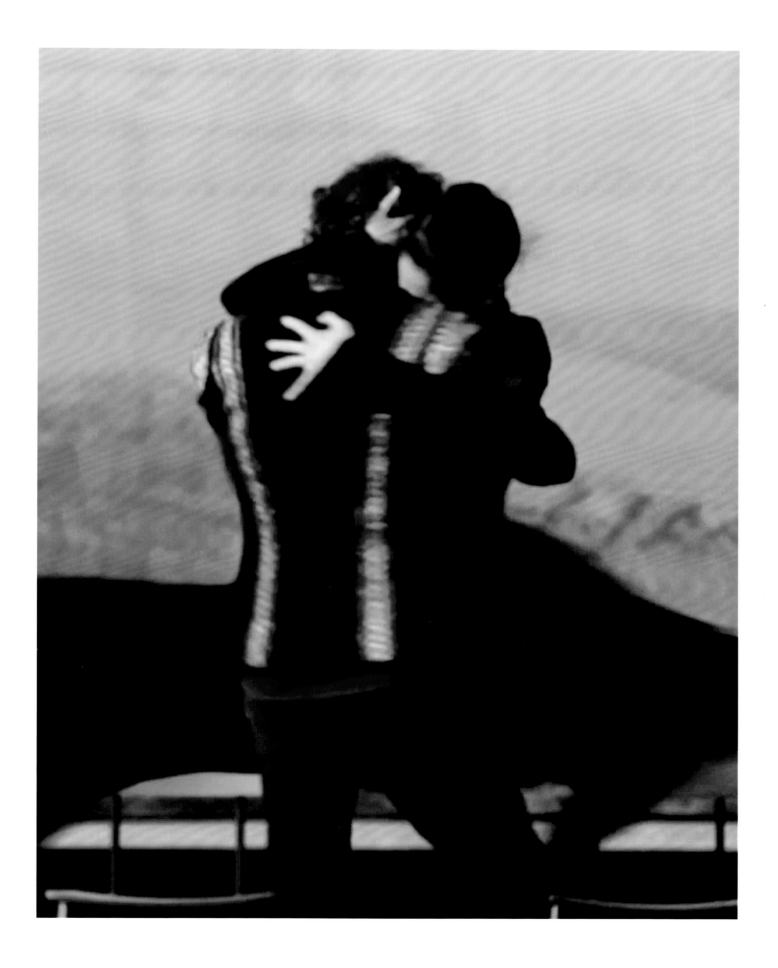

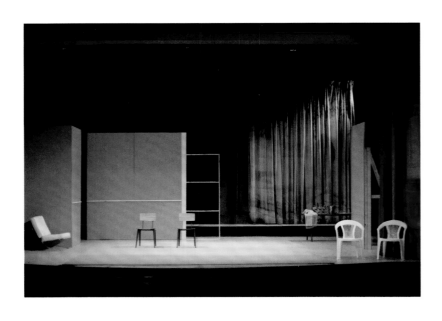
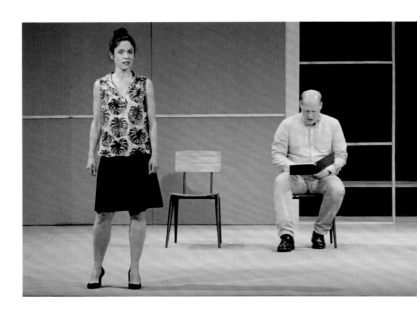

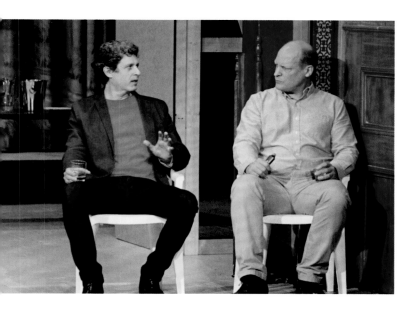
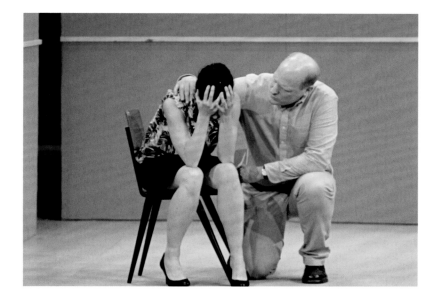
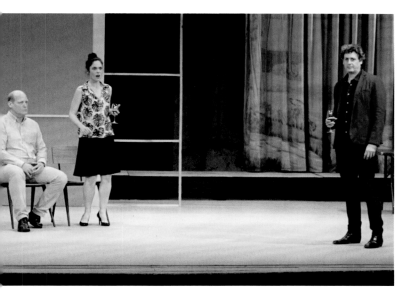
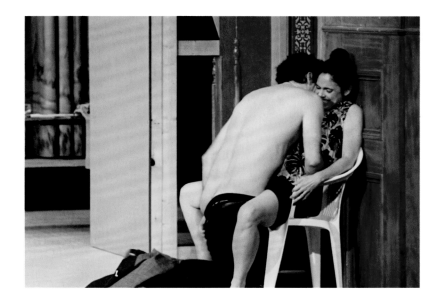

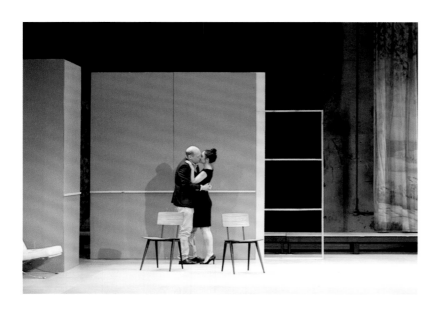
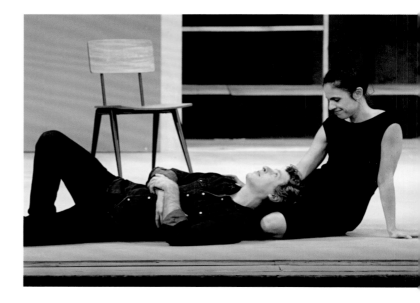
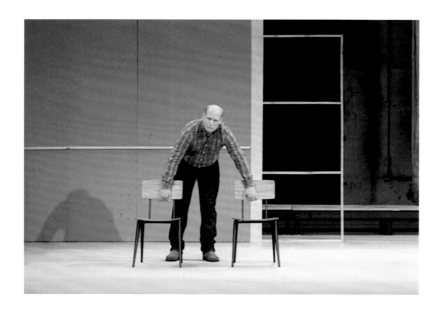
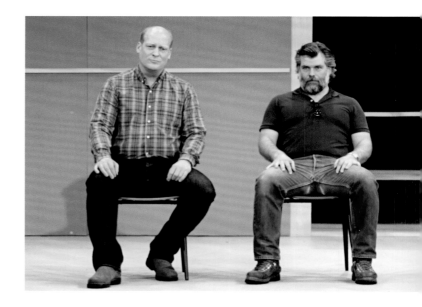

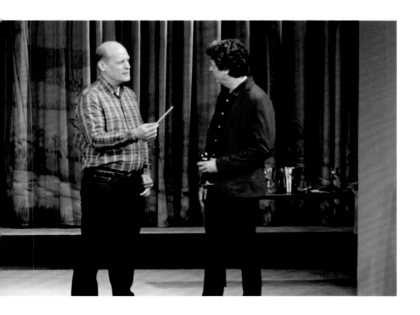 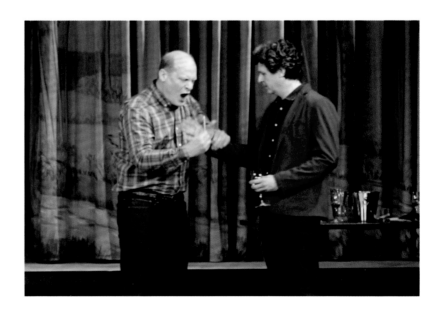

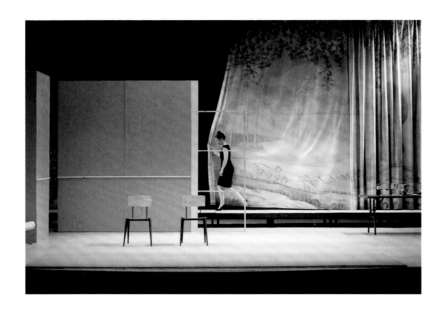
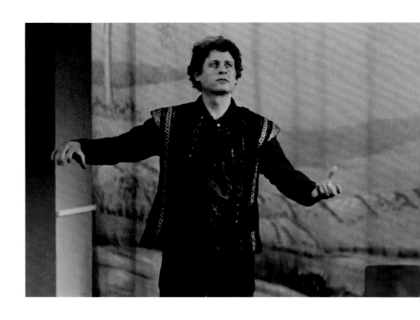

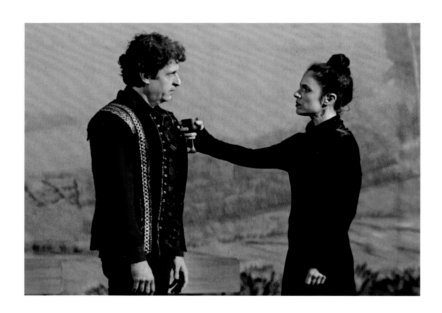

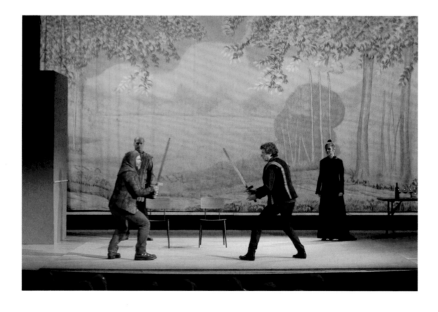
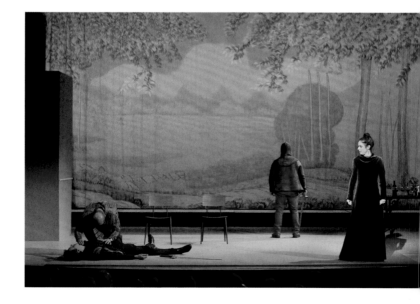

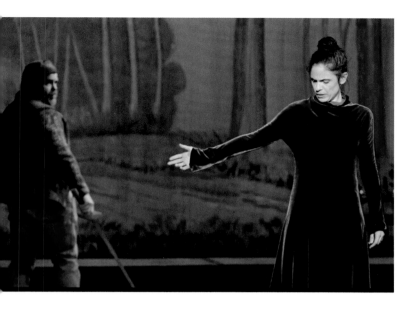
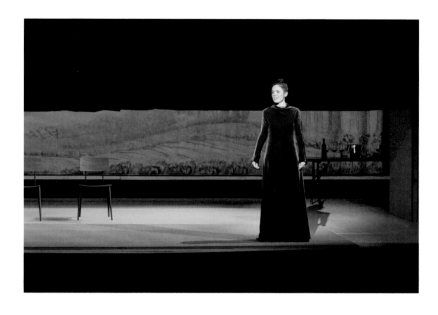

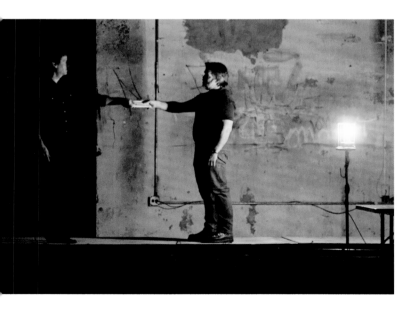

The Evening

The actor playing Beatrice describes Richard Maxwell's father's death. Beatrice is a bartender/prostitute in a bar. Asi is a fighter and Cosmo is his manager. Cosmo wants to celebrate Asi's win, but Asi wants to talk about getting more fights. Beatrice tells Asi she wants to go to Istanbul, but Asi wants her to stay. A band enters and sets up as Asi takes his steroids. Cosmo wants them all to have fun. They dance as the band plays. Asi realizes Cosmo gave Beatrice money for her trip and gets angry. Asi and Cosmo fight. Asi steals Beatrice's phone. Beatrice pulls a gun on the two men and gets her phone back. Beatrice tells Cosmo she wants to escape, and they talk about whether they're losers or not. Cosmo encourages her to go. He tries for her gun, and fails. Beatrice orders the men to say what they are. She shoots Asi. He doesn't die. She shoots Cosmo and he doesn't die either. Beatrice removes their squib packs. She takes out her suitcase and steps out of the bar and the bar comes apart. Asi and Cosmo exit. The stage fills with fog and turns white. The actor playing Beatrice puts on snow camouflage, then describes a journey through a vast landscape.

Written and Directed by Richard Maxwell

Beatrice Cammisa Buerhaus
Cosmo Jim Fletcher
Asi Brian Mendes

Band: James Moore, Andie Springer, David Louis Zuckerman

Set and Lights: Sascha van Riel
Costumes: Kaye Voyce
Producer: Regina Vorria

The Kitchen
New York 2015

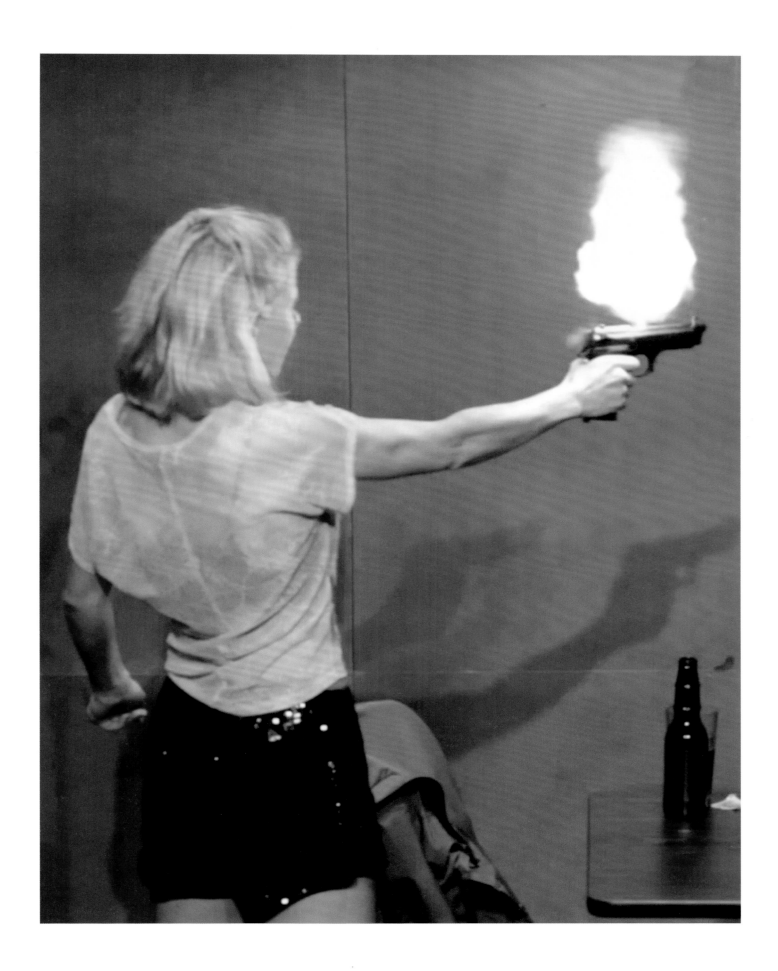

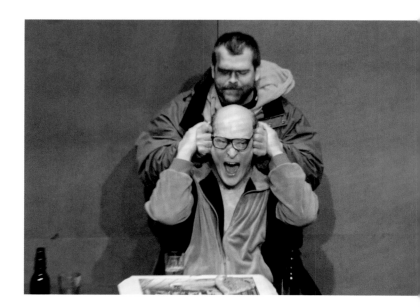

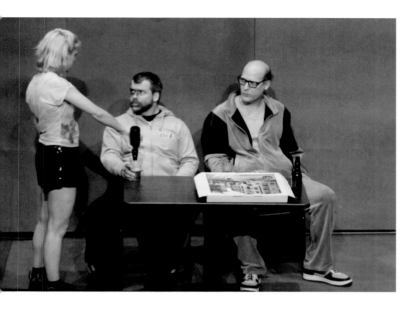

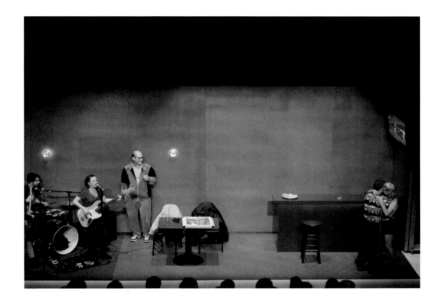
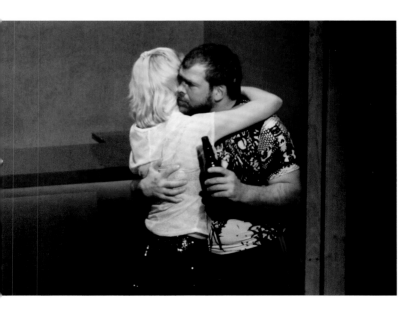
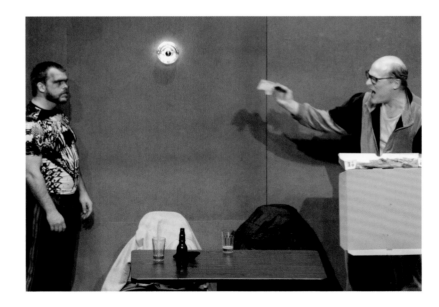

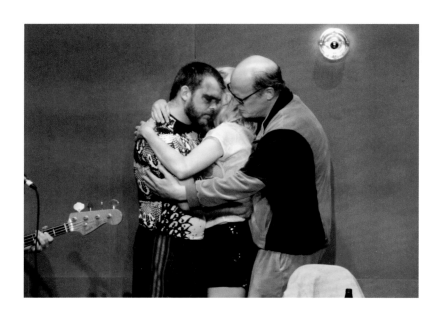
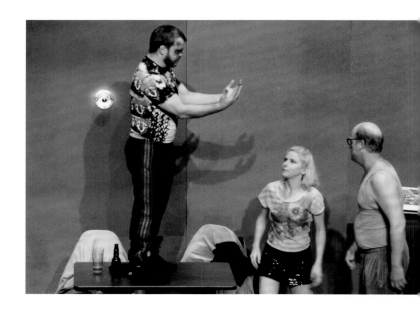
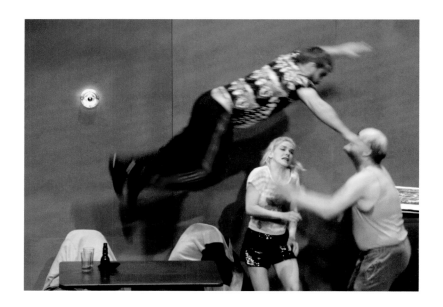
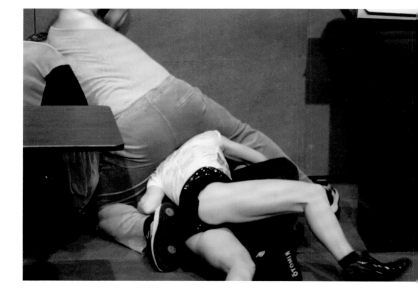
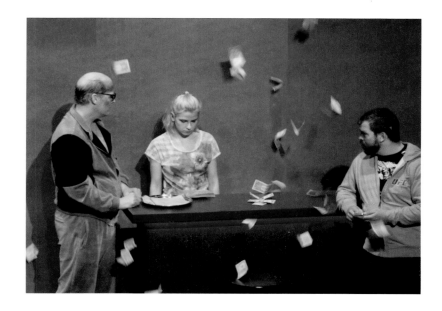
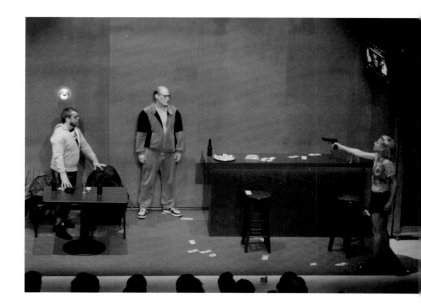

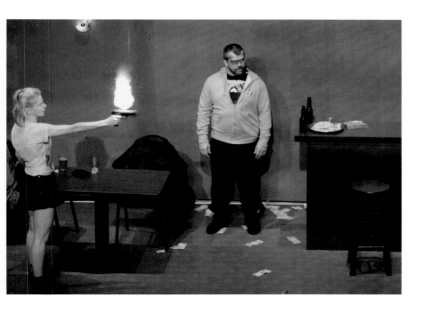
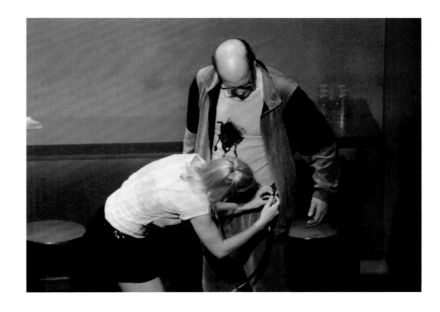
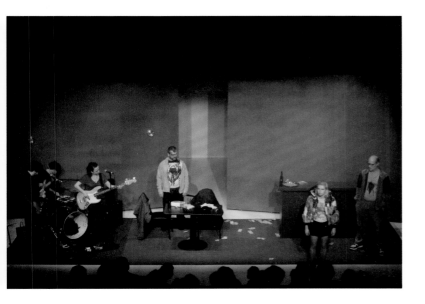
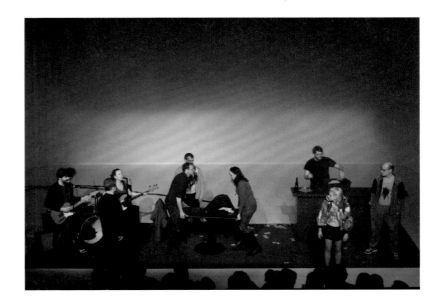
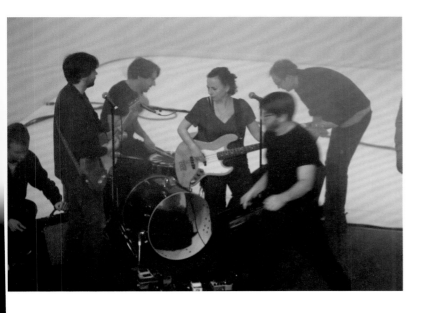

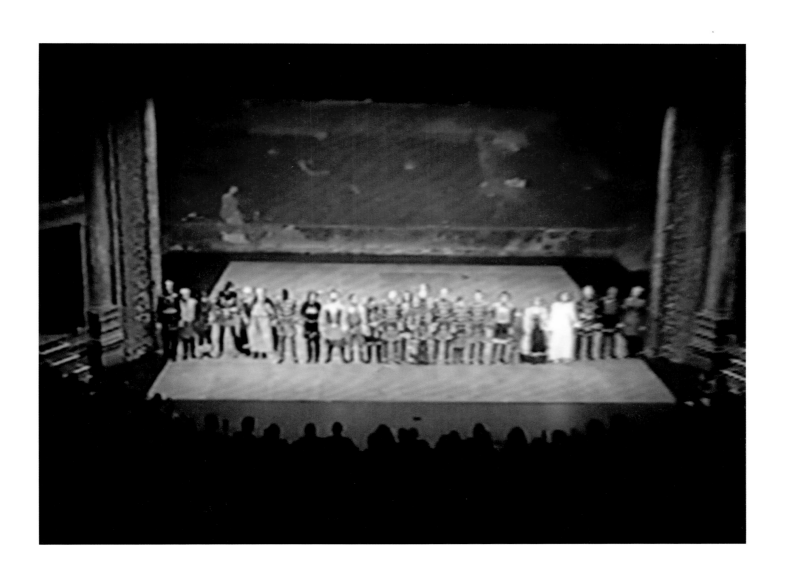

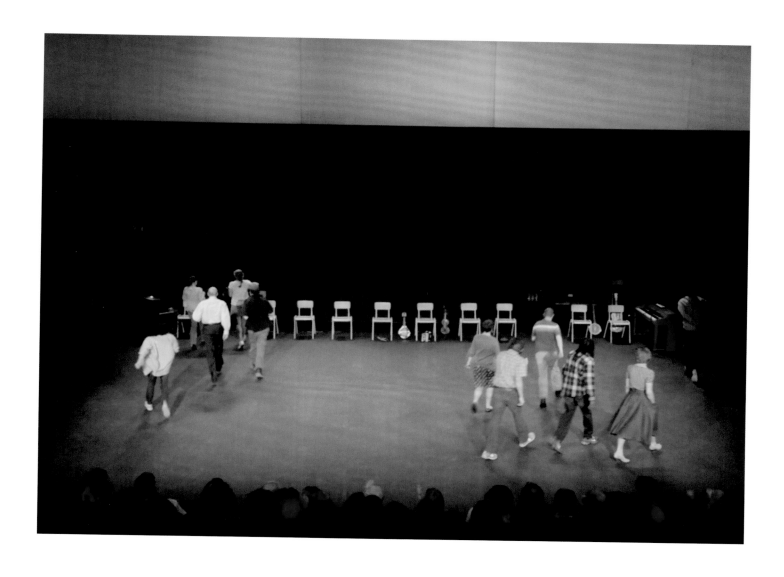

Richard Maxwell and New York City Players
The Theater Years

Editors:
Jim Fletcher
Richard Maxwell
Robert Snowden

Image Contributors:
Jim Fletcher
Ying Liu
Richard Maxwell
Michael Schmelling
Robert Snowden

Synopses:
Emily Hoffman

Design and Production:
Michael Schmelling /40 Worth St.

Video Documentation:
Warren Avery, John Barr, Erica Heilman, Ros Kavanagh, Ken Kobland, Richard Maxwell, Gary Prusaitis, Sascha van Riel, Michael Schmelling, Jim Strahs, and Tory Vazquez

New York City Players' general operating support provided by the Howard Gilman Foundation.

Program support provided by the Andrew W. Mellon Foundation Theater Program, Arts International, the Barbara Bell Cumming Foundation, the Creative Capital Foundation, the Doris Duke Foundation, the Foundation for Contemporary Arts, the Greenwall Foundation, the Jerome Foundation, the Mid Atlantic Arts Foundation's USArtists International, National Endowment for the Arts, New York City Department of Cultural Affairs in partnership with the City Council and the New York State Council on the Arts, with the support of Governor Andrew Cuomo and the New York State Legislature, Peg Santvoord Foundation, and the Rockefeller Foundation.

Additional support provided by the Alliance of Resident Theatres' New York Creative Space Grant. Production design support provided by the Edith Lutyens and Norman Bel Geddes Design Enhancement Fund, a program of the Alliance of Resident Theatres/New York (A.R.T./New York).

Thanks to Emmy Catedral, Louris van de Geer, Carol Greene, Chloe Truong-Jones, Anna Rubin, Jay Sanders, Andrew Schlager, Tory Vazquez, Regina Vorria, and Thea Westreich Wagner and Ethan Wagner

ISBN 978-0-9979647-0-7

© Richard Maxwell

Published by Westreich Wagner and Greene Naftali

Westreich Wagner

GREENE NAFTALI

Distributed in North America by Artbook / DAP

Printed in May 2017 by Optimal Media, Germany

Production Notes:

Cowboys And Indians (1999) Produced by Soho Rep., New York.

Showy Lady Slipper (1999) A co-production of Exit Festival and the Hebbel Theater.

Boxing 2000 (2000) A co-production of the Walker Art Center and the Hebbel Theater.

Caveman (2001) A co-production of Festival d'Automne à Paris and Soho Rep.

Drummer Wanted (2001) A co-production of Festival Theaterformen 2002 and the Wexner Center for the Arts with support from the Doris Duke Charitable Trust.

Joe (2002) A co-production of the Barbican, the Walker Art Center and the Wexner Center for the Arts with the support from the Doris Duke Charitable Trust.

Henry IV Part 1 (2003) A co-production of Brooklyn Academy of Music's Next Wave Festival, BITE:03 at the Barbican, and the Hebbel Theater.

Good Samaritans (2004) A co-production of Biennale Bonn and the Lyric Hammersmith.

The End Of Reality (2006) A co-production of The Kitchen, BITE:06 at the Barbican, the Wexner Center for the Arts with support from the Doris Duke Charitable Trust, the Steirischer Herbst Festival 2006, the Walker Art Center, and Judith and Richard Greer.

Ode To The Man Who Kneels (2007) A production of the Festival Belluard Bollwerk International, in co-production with Arsenic, Auawirleben, Buda Kunstencentrum, Théâtre du Grütli, and Kunstencentrum Vooruit. It was made possible thanks to a contribution of Canton Fribourg. New York production partner: Piece by Piece Productions.

People Without History (2009) A co-production of Project Arts Centre.

Neutral Hero (2011) A production of Kunstenfestivaldesarts, with executive production by New York City Players. A co-production of Wiener Festwochen, Festival d'Automne à Paris, Les Spectacles vivants-Centre Pompidou, Kampnagel, Hebbel am Ufer (HAU), Théâtre de l'Agora, Scène Nationale d'Evry et de l'Essonne, Festival TransAmériques, De Internationale Keuze van de Rotterdamse Schouwburg, La Bâtie-Festival de Genève, and Théâtre Garonne.

Isolde (2014) A production of Theater Basel in September 2013. Also developed in residency with the Lower Manhattan Cultural Council and presented by New York City Players at Abrons Arts Center in New York in 2014. Received its Off-Broadway premiere at Theatre for a New Audience (Jeffrey Horowitz, Founding Artistic Director; Henry Christensen III, Chairman; Dorothy Ryan, Managing Director), Polonsky Shakespeare Center, Brooklyn, New York, Fall 2015.

The Evening (2015) 2014 Spalding Gray Award commission from the consortium of Performance Space 122, the Andy Warhol Museum, On the Boards, and the Walker Art Center. A co-production of Kunstenfestivaldesarts, with additional generous support provided by Greene Naftali and The Kitchen.